Boston's SOUTH SHORE

Boston's

South Shore

Photographs by Greg Derr
Text by Amy Whorf McGuiggan

Commonwealth Editions

Beverly, Massachusetts

For Judy, Nicholas, and Sophia

Library of Congress Cataloging-in-Publication Data
Derr, Greg.
Boston's South Shore / photographs by Greg Derr; text by Amy Whorf McGuiggan.
p. cm.
ISBN 1-889833-77-0
1. South Shore (Mass. : Coast)—Pictorial works. 2. South Shore (Mass. : Coast)—
Description and travel. I. McGuiggan, Amy Whorf, 1956– II. Title.
F72.P7D47 2005
917.44'61— dc22 2005012287

ISBN-13: 978-1-889833-77-4
ISBN-10: 1-889833-77-0

Text and captions by Amy Whorf McGuiggan.
Jacket design and interior layout by Anne Rolland.
Printed in China.

Commonwealth Editions
266 Cabot Street, Beverly, Massachusetts 01915
www.commonwealtheditions.com

Images on pages 11, 31, 44–45, 103, and 115 are reprinted
with permission of the *Patriot Ledger*.

Front jacket: Lobster boat, Scituate Harbor
Back jacket: *Mayflower II* (top left), Tree-Berry Farm, Scituate (top right),
Hancock Cemetery and United First Parish Church, Quincy (bottom)
Front jacket flap: North River, Marshfield
Title page: The Gurnet, Plymouth
Page 5: Sailboats, Cohasset
Page 6: On the marsh, Duxbury

CONTENTS

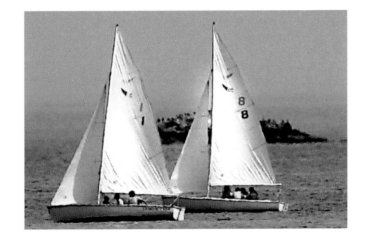

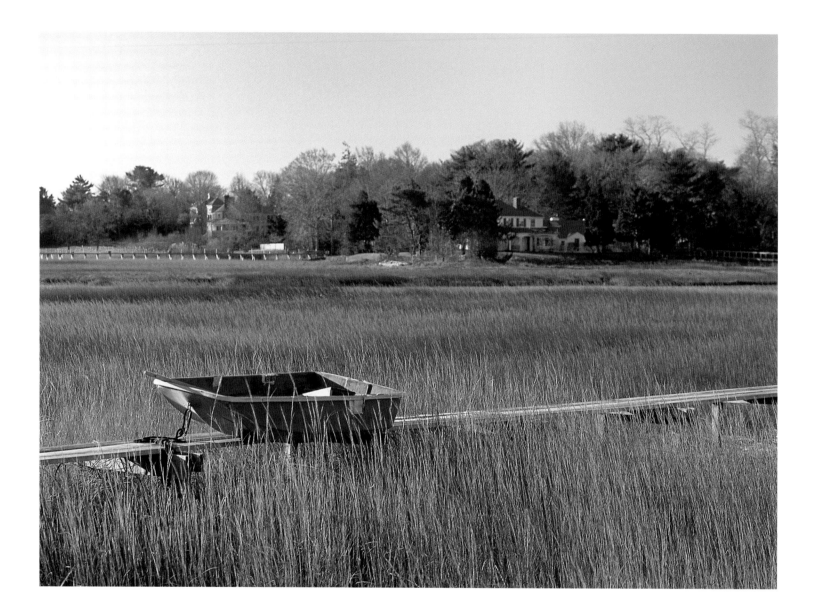

FOREWORD

Traveling the south shore of boston is like watching a giant crazy quilt unfurl. The shore begins, most folks will agree, as one leaves Boston and crosses the Neponset River, a natural waterway that has played a key role in the region's fortunes. Native Americans used the river to transport furs and skins. Later, grist mills, lumber mills, paper mills, and chocolate mills dotted its banks, and a thriving shipbuilding industry turned out small vessels called shallops. By the Revolutionary War era, the river had become an important avenue for South Shore commerce. Today, though hints of its industrial past remain, the Neponset River—and its swaths of marshland—is most cherished as a greenway, an open space restored and preserved for public use. Rich with diverse plant and animal life, the river's watershed reaches deep into the South Shore.

Some sixty miles away, the South Shore ends at the Cape Cod Canal, a man-made waterway that separates the "bare and bended arm" of Cape Cod from the mainland. But this place between the waterways, our "South Shore," is not one place, but a patchwork of places—each with a unique history, character, and vitality. The common thread in this quilt is the sense of community, a shared history of nearly four hundred years, a history of which each town is individually and collectively proud.

It was on the South Shore that an intrepid band of Pilgrims, seeking a new start in a new world, established their plantation at Plymouth in 1620. Having dropped anchor first in what is now Provincetown Harbor at the tip of Cape Cod, they might have colonized that outpost, but impoverished soil and a lack of good drinking water forced them to push on to a farther shore. They found everything they needed at Plymouth. By 1630, Boston to the north had been settled, and over the next years seafaring and shipbuilding villages, farms, and mills sprouted along and behind the coast between Boston and Plymouth.

One can't tell from the map, but the coastline south of Boston does not have the rocky ruggedness of Boston's North Shore. Instead, the edge that meets Massachusetts Bay is mostly a scarf of golden sand that tumbles down from Quincy into Weymouth. Scooped out at Hingham, the shoreline turns back on itself at Hull, where the gentle curve of Nantasket Beach confronts the ocean. Only at Cohasset does the shore show a craggy face to the sea.

Between Scituate and Marshfield, the North River snakes inland through a patchwork of nutrient-rich marshland, gently rolling hills, and fertile valleys. Fragile barrier beaches shelter the harbors of Duxbury, Kingston, and Plymouth. Then the shore coasts toward Cape Cod.

If, for too many years, the South Shore played second fiddle to the North Shore, it does so no longer. When earlier generations of Bostonians were fleeing to the invigorating air of the Green and White mountains in Vermont and New Hampshire to escape the oppression of city summers, and when getting there was arduous, the North Shore became a natural jumping-off point. Not until Cape Cod, too, became a fashionable summer getaway did the South Shore begin to come into its own, realizing its potential after being "discovered" by Boston's second- and third-generation Irish families looking for their own slice of the American Dream after World War II.

Today, what folks find when they visit the South Shore for a day or stay for a lifetime is a region rich in history. Indeed, the history of our nation—from first footings to Revolutionary War to China Trade to immigration—is recorded in the annals of South Shore towns.

It is a place, still, of Native American names and charming monikers that recall gentler times. It is a place of manicured town greens with whitewashed bandstands and gazebos, Fourth of July parades, New England–style town meetings, farmers' markets, stately old meetinghouses, and clapboarded Cape Cod and colonial homes surrounded by picket fences. It is a place of meandering roads fashioned from the old byways that were once cow paths, Native American trails, and stagecoach roads, a place where it is still easy to imagine how things looked a century ago.

It is a place of natural beauty: Blue Hills that spread across five towns; roadways that blaze every autumn with sugar maples, sheltered beaches, tranquil coves, and inviting harbor islands; aromatic pine forests, glassy lakes, and burgundy red cranberry bogs that remind us not only of nature's bounty, but of the region's deep, enduring agricultural roots.

If the South Shore was once a thoroughly Yankee region, it is no longer. When the Irish found the American Dream on the South Shore—their "Riviera"—they began paving the way for other modern-day pilgrims. Today, the region boasts a multicultural population including Asians, Latinos, Middle Easterners, Cape Verdeans, and Brazilians, all sharing a place that since our nation's founding has embraced anyone with the dream of a new life and a better tomorrow.

Such is the crazy quilt that is the South Shore. Come wrap yourself in it and enjoy its warmth.

Amy Whorf McGuiggan
Hingham, Massachusetts
April 2005

Boston's SOUTH SHORE

QUINCY, BRAINTREE, & MILTON

Quincy, Braintree, and Milton are closely linked in history. Braintree, at its incorporation in 1640, included area that is, today, Quincy and Milton. By 1792, the North Precinct of Old Braintree and part of Dorchester had become the town of Quincy. Milton, too, sprang from Old Braintree and Dorchester. All three communities were early fishing and trading settlements. Their proximity to Boston and the Neponset River waterway enabled them to thrive very early on.

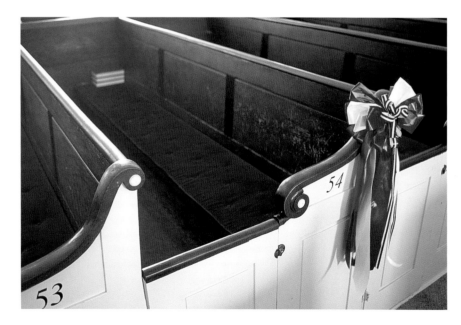

A pew in United First Parish Church ("Church of the Presidents"), Quincy (above), is decorated with a ribbon in memory of the Adams families who worshipped here. Traffic flows through the busy center of Quincy (right), the economic and commercial heart of the South Shore.

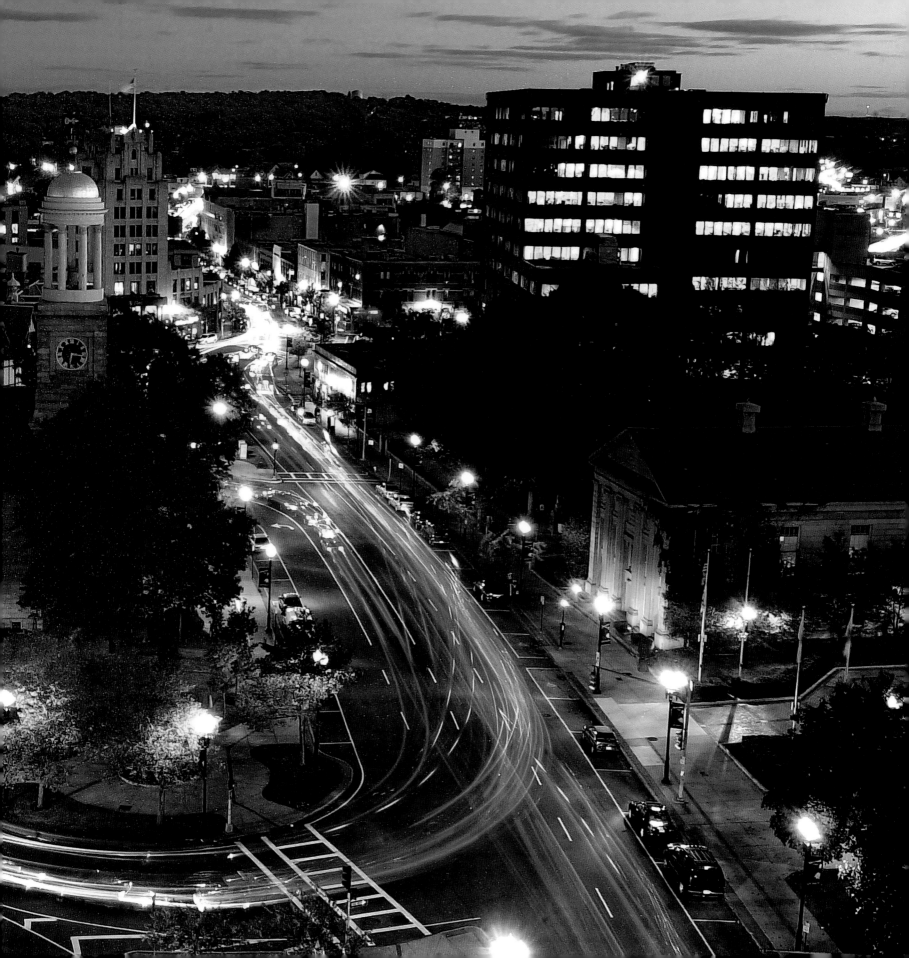

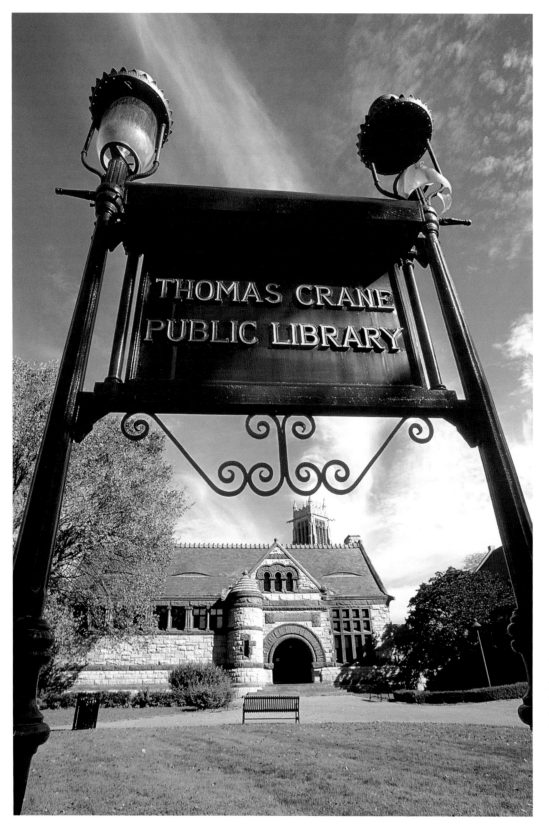

The Thomas Crane Public Library, designed by Henry Hobson Richardson, sits on a foundation of Quincy granite. A National Historic Landmark, it was built in honor of Thomas Crane, who made his fortune in the stone industry.

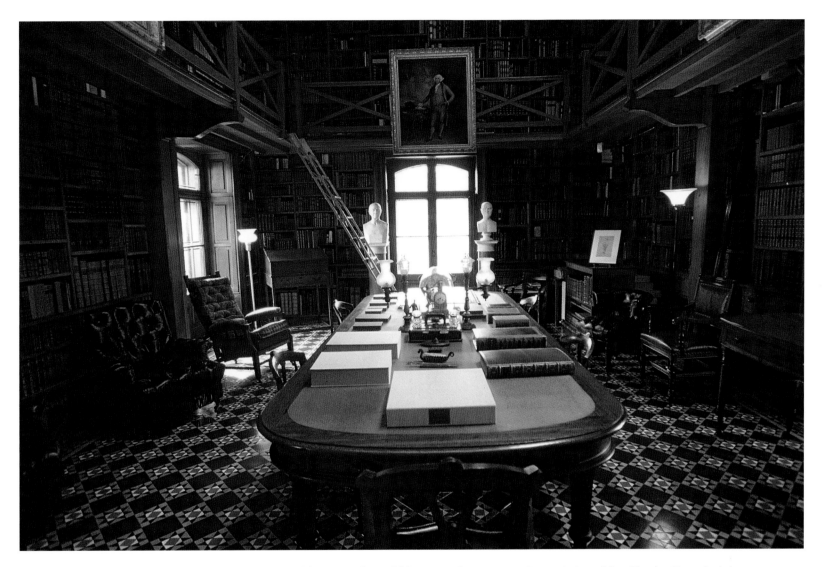

Also in Quincy is the Stone Library, the oldest presidential library in the country. Commissioned by Charles Francis Adams to honor his father, President John Quincy Adams, it is situated on the grounds of the "Old House," where John and Abigail Adams retired in 1801.

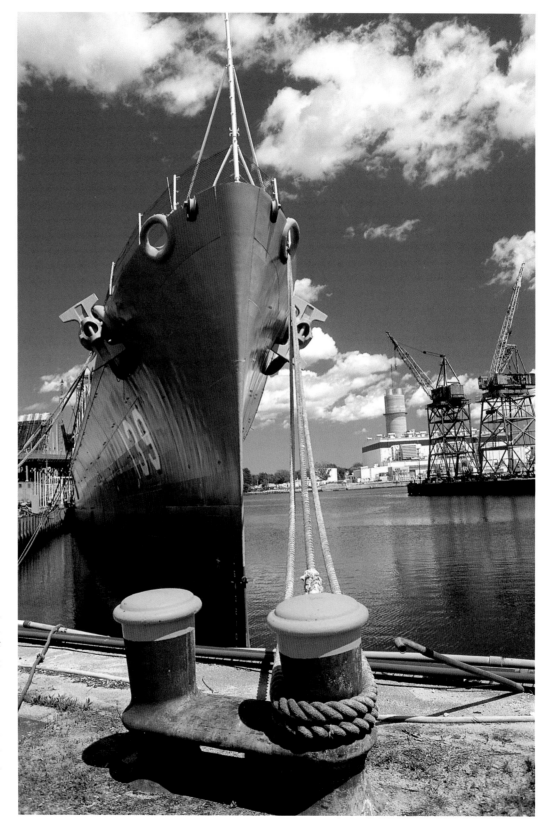

The USS *Salem*, berthed at Quincy's historic Fore River Shipyard, is a symbol of Quincy's proud shipbuilding tradition. It now houses a collection of military memorabilia and displays about shipbuilding and shipboard life. Until the shipyard—where more than 700 vessels were built and launched—closed in the 1980s, "Quincy built" signified the finest ships afloat.

The Children's Church in Milton was originally a one-room school-house on the grounds of the Captain Robert Bennet Forbes estate. It was moved and remodeled in 1937 as a smaller version of the 1787 First Parish Unitarian Universalist Church (the "Meetinghouse") just across the lawn. The Children's Church, scaled to accommodate its "small" congregation, can also comfortably seat seventy-five adults.

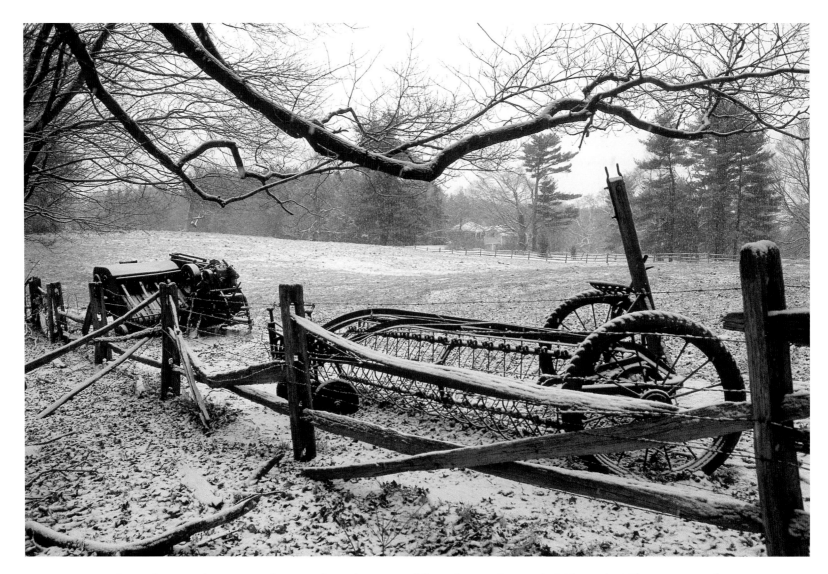

Rusty farm equipment weathers another winter snowfall on Canton Avenue in Milton. As Milton prospered during the China Trade, grand, fashionable residences surrounded by sprawling farms were built, and an aristocratic air settled over the town.

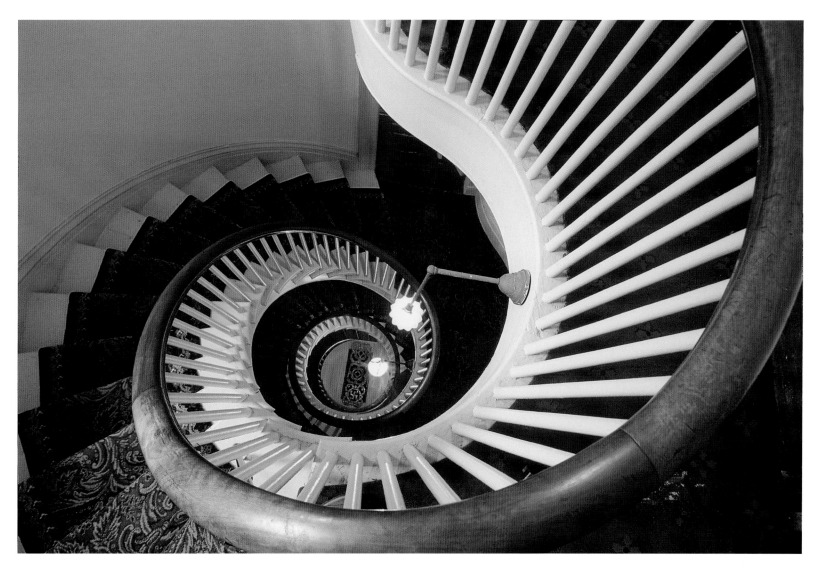

A majestic lighthouse stairwell winds down through the Captain Forbes House Museum in Milton. Situated in the heart of the Milton Hill Historic District overlooking Boston Harbor, the 1833 Greek Revival mansion was built by Captain Robert Bennet Forbes, a wealthy merchant, ship owner, and philanthropist, for his mother. The Forbes family was among the prominent families who encouraged and expanded trade with China and helped bring the port of Boston to prominence during the sailing ship era.

A light snow dusts the banks of the Great Pond Reservoir in Braintree, giving it an ethereal mood. The reservoir, which attracts shorebirds and diving ducks, is the main water supply for Braintree and several of its neighboring communities.

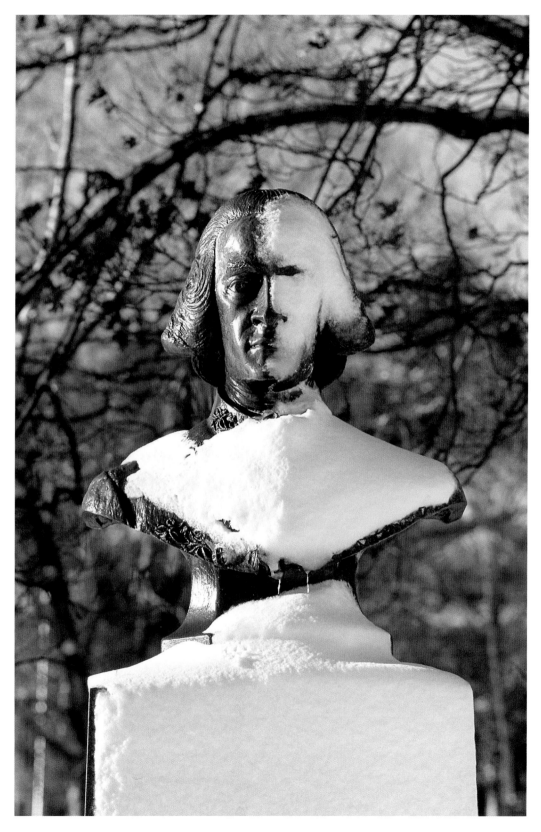

A bronze bust of John Hancock, patriot, first signer of the Declaration of Independence, and Massachusetts governor, sits on a foundation of Quincy granite at Adams Academy in Quincy, the site of his birthplace. Adams Academy was the gift of John Adams, Hancock's boyhood friend, and became one of the best prep schools of its day. Today it is the headquarters of the Quincy Historical Society.

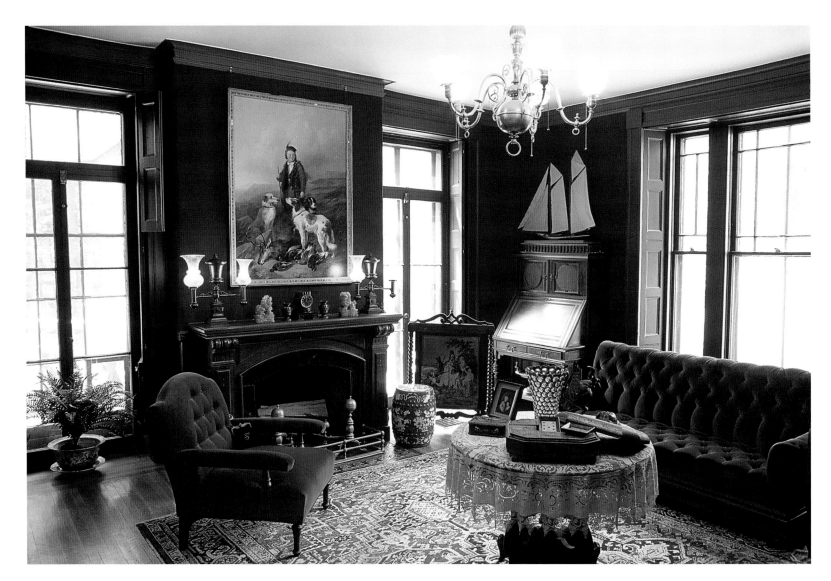

Restored to 1870s Victorian splendor, the Captain Forbes House Museum interprets the social and cultural history of the era through tours, lectures and special events. A National Historic Landmark, the museum boasts an impressive collection of furnishings, European and Chinese porcelains, Civil War artifacts and Lincoln memorabilia, including a replica of Lincoln's log cabin. The museum's grounds offer exotic Asian plantings as well as dramatic views of Boston.

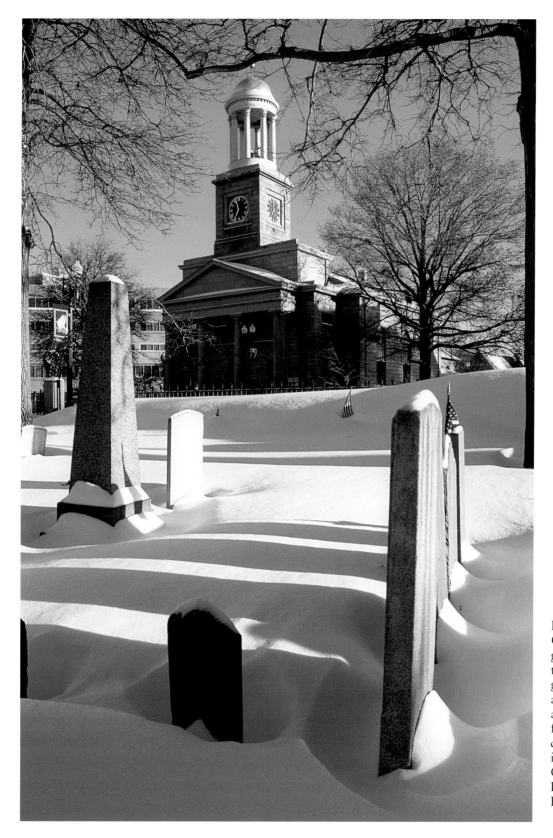

Hancock Cemetery, Quincy's central burial ground until 1854, is the resting place of generations of Adamses and Quincys, as well as of John Hancock's father, Rev. John Hancock. Across the street is United First Parish Church, "Church of the Presidents," where Rev. Hancock preached.

21

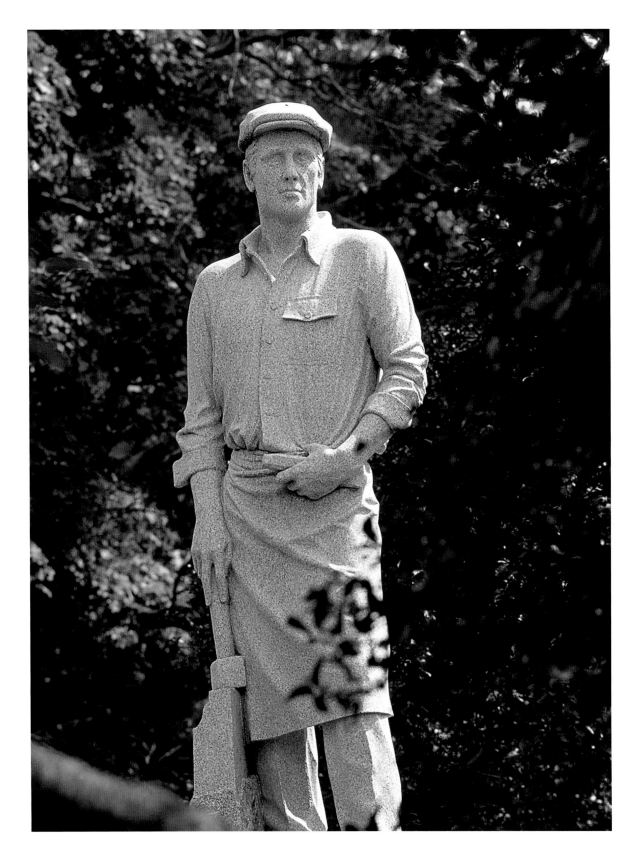

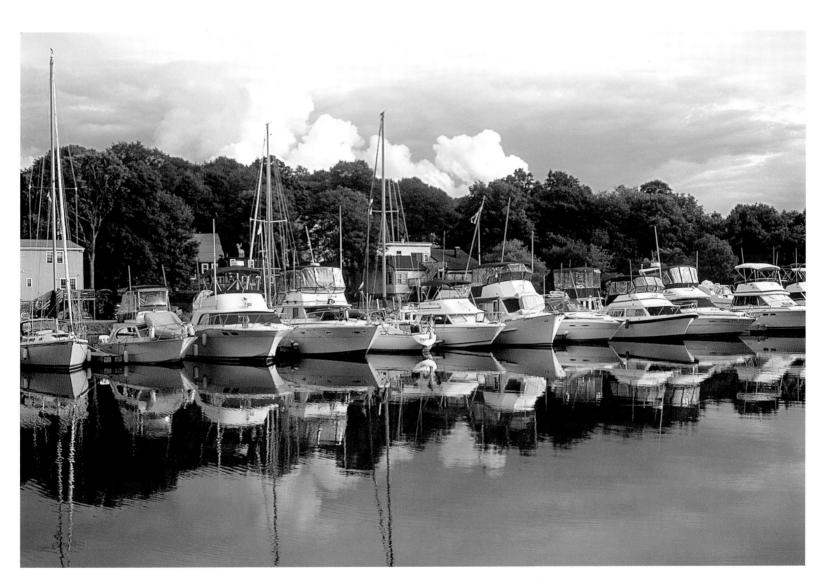

Pleasure boats fill berths at the Braintree Yacht Club (above). The South Shore's proximity to the Boston Harbor Islands National Park makes the region popular with boaters.

A stonecutter's memorial in West Quincy (left) pays tribute to immigrants from Italy, Scotland, Finland, Sweden, Sudan, and other countries who made Quincy a thriving center for granite production. A hard and weather-resistant stone that polishes brilliantly, Quincy granite came to be synonymous with high quality throughout the world.

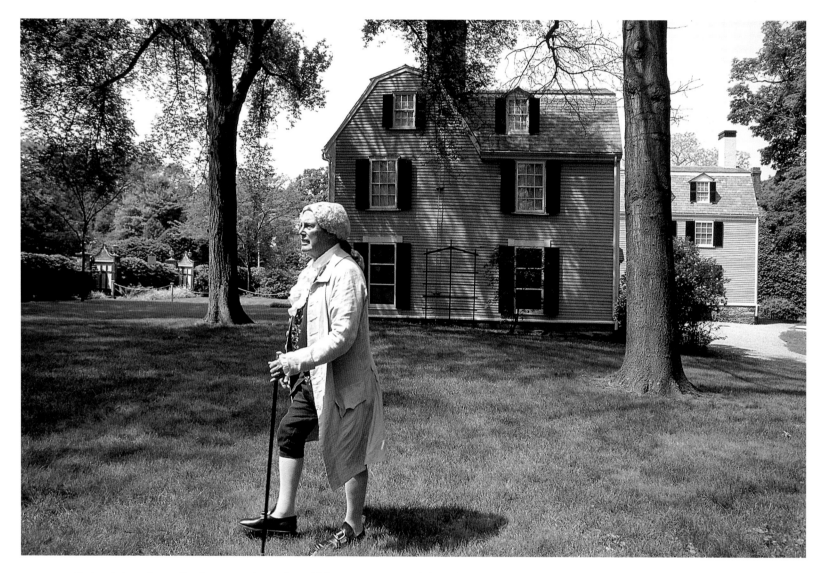

"John Adams" strolls the grounds at the "Old House," part of the Adams National Historic Site. John and Abigail Adams purchased the estate in 1787 and named it Peacefield. It was from here that Adams carried on his legendary correspondence with Thomas Jefferson. The house stayed in the Adams family until 1927.

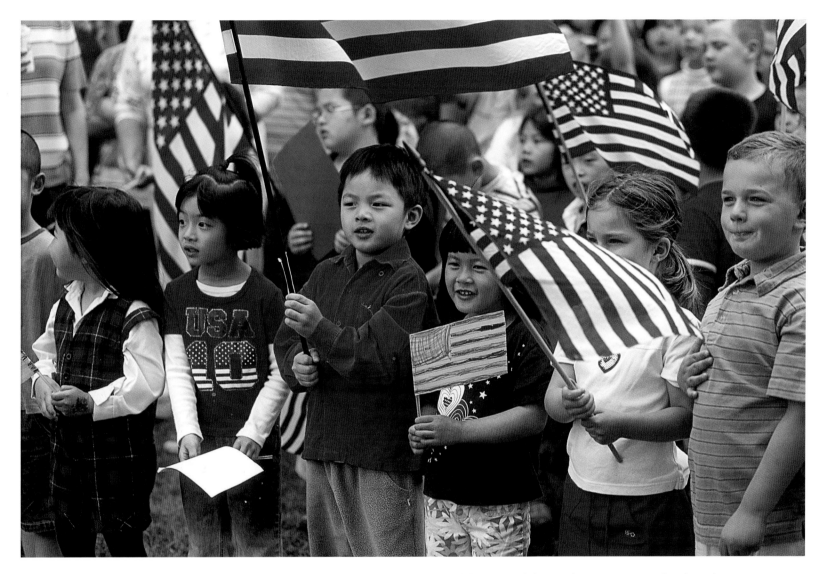

Quincy schoolchildren, reflecting the ethnic and cultural diversity of the city, celebrate Flag Day. A city that has always welcomed immigrants, Quincy is now home to the largest Asian population on the South Shore.

The birthplace of Braintree's native son General Sylvanus Thayer, now headquarters of the Braintree Historical Society, was built in 1720. Thayer served with distinction during the War of 1812 and later became known as the "Father of West Point" after modernizing its curriculum. He also designed the Civil War–era Fort Warren—constructed of hand-hewn Quincy granite—on Georges Island in Boston Harbor.

Adams Field in Merrymount Park has always been the pride of Quincy, but recent renovations and upgrades have made it a world-class amateur ballpark. In 2003, it hosted the 14-year-old Babe Ruth World Series. On warm summer evenings, baseball fans from across the South Shore gather at Adams Field to take in the national pastime.

WEYMOUTH, HINGHAM, HULL, & COHASSET

Close enough to Boston to thrive, but just far enough away to retain their "village" atmosphere, the towns of Weymouth, Hingham, Cohasset, and Hull always relied on the sea to sustain their residents. Weymouth was founded as a fishing and trading post in 1622, just two years after the Pilgrims settled in Plymouth. Hingham and Cohasset boasted large mackerel fleets and Hull residents earned a reputation as "lifesavers" for their heroic rescues of mariners shipwrecked during the nineteenth and twentieth centuries. Later, Cohasset and Hull became fashionable summer seaside resorts.

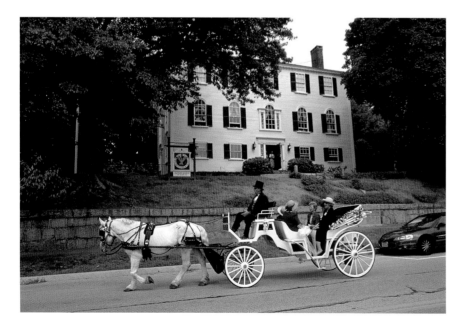

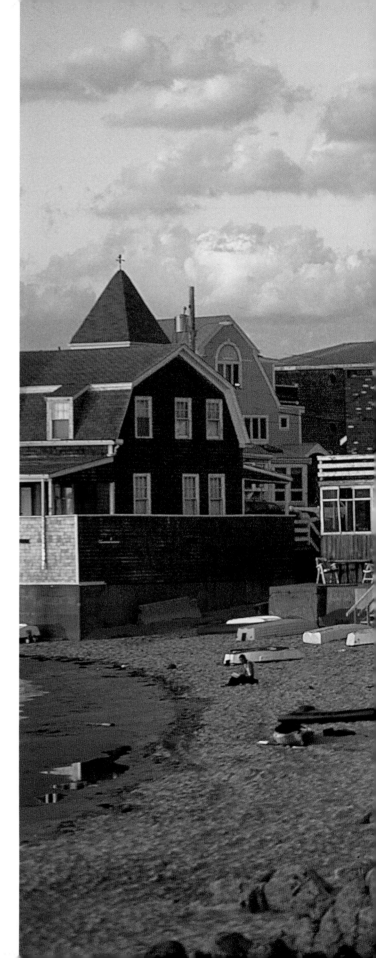

A carriage brings guests to a party at Old Derby Academy in Hingham, now headquarters of the Hingham Historical Society (above). Summer cottages reflect the late afternoon light at Hull's Gun Rock Beach (right).

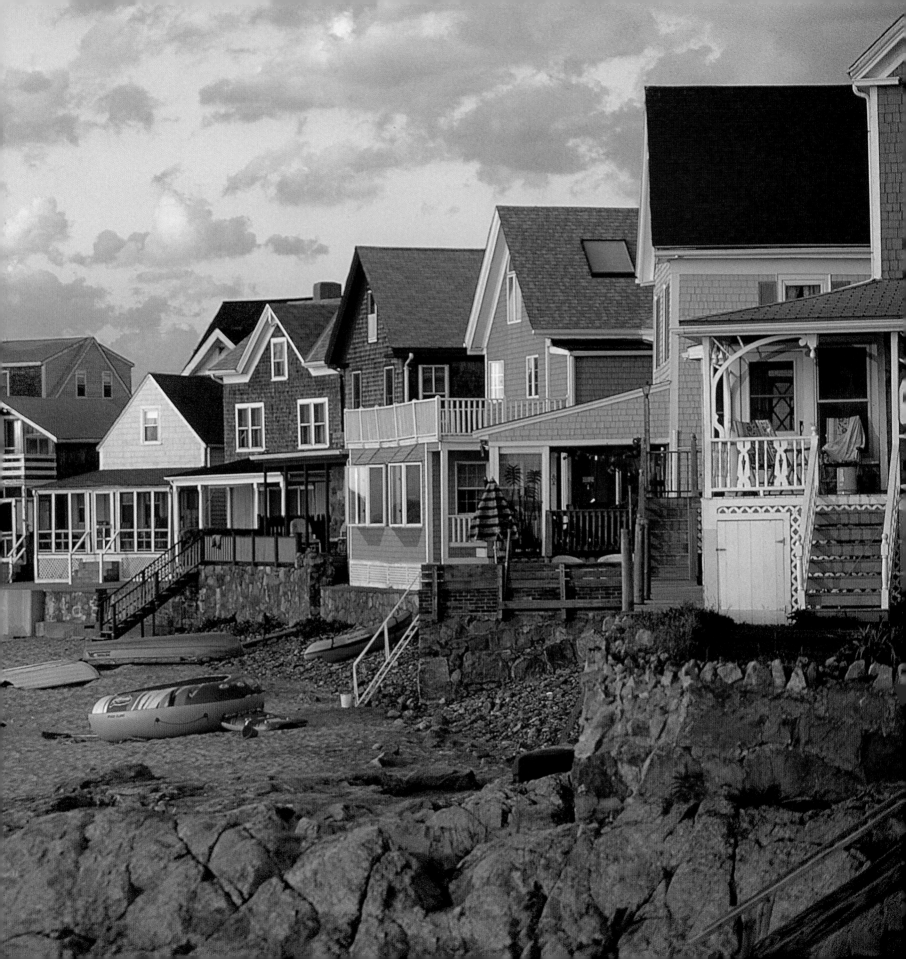

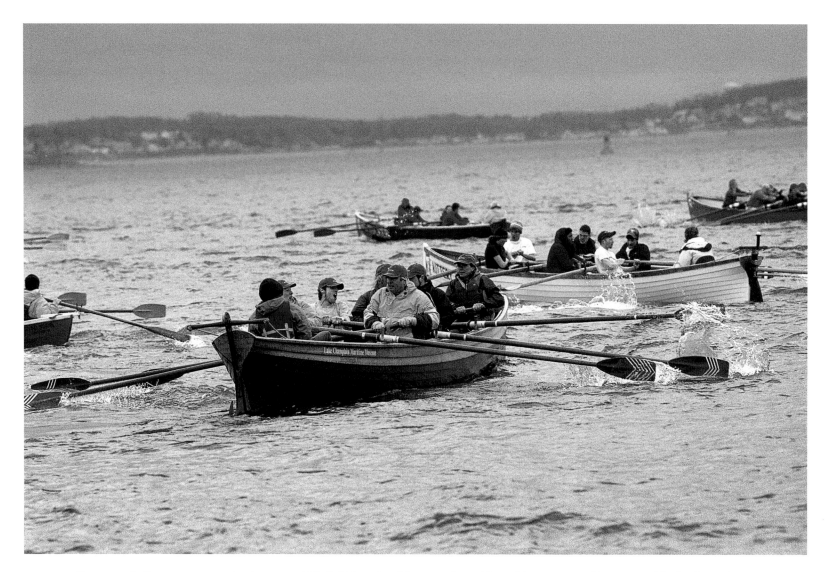

Rowers of all ages compete in the annual Hull Lifesaving Museum Snow Row. Now twenty-five years old, the Snow Row is held in late winter—when the weather is at its most unpredictable—and challenges rowers to a 3 3/4-mile triangular course. Dozens of rowers come from all over New England (and from the United Kingdom) to participate, competing in beautifully restored wooden boats of all kinds.

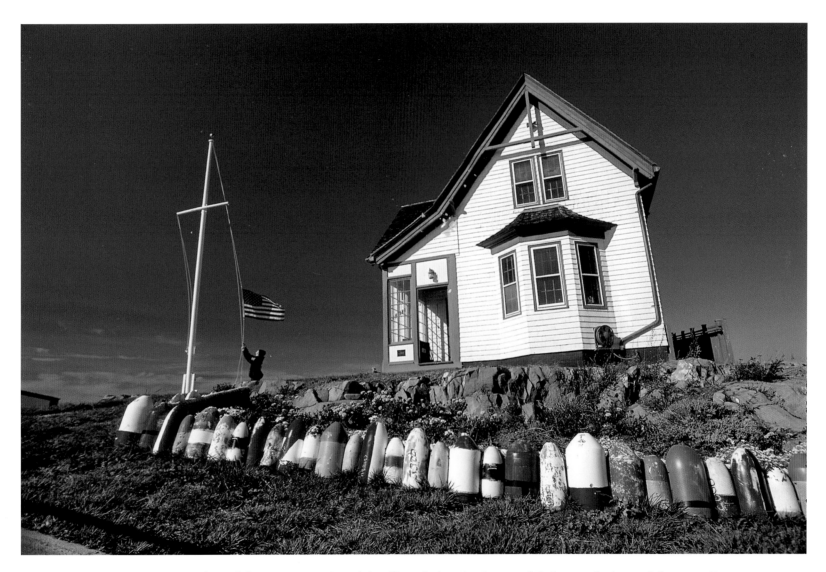

Sally Snowman, member of the U.S. Coast Guard Auxiliary, hoists the Stars and Stripes at the keeper's house at Boston Light on Little Brewster Island in Outer Boston Harbor. Located in Hull, in Plymouth County, and powered by electricity supplied by Hull Wind, Boston Light is the oldest lighthouse station in the country, established in 1716. Still an active aid to navigation, the National Historic Landmark was the last American lighthouse to be automated and the only American light still manned by Coast Guard personnel.

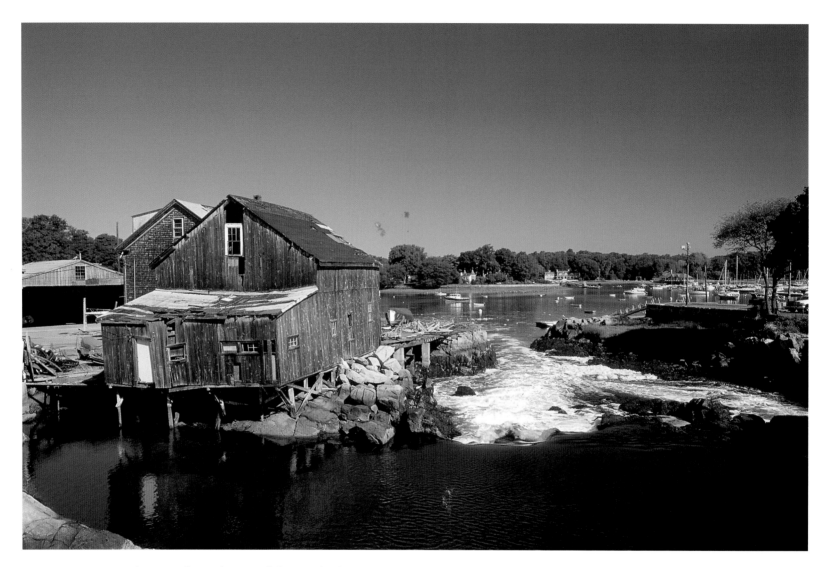

The Bound Brook, one of the South Shore's major coastal watersheds, flows into Cohasset Harbor past an abandoned boat works and boat railroad, once used to launch boats into the harbor.

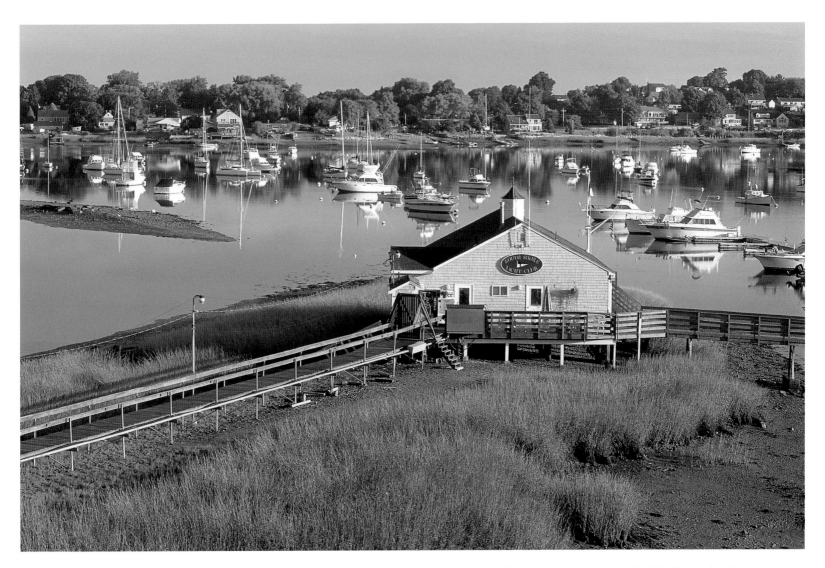

Often described as a small, easy-going yacht club, the South Shore Yacht Club sits atop a patch of tidal flat and salt marsh in Weymouth's Back River basin. The 950-acre Back River, a designated Area of Critical Environmental Concern (ACEC), is a fragile ecosystem of tidal waters and flats, salt marsh, salt ponds, and uplands with glacial eskers and prehistoric sites.

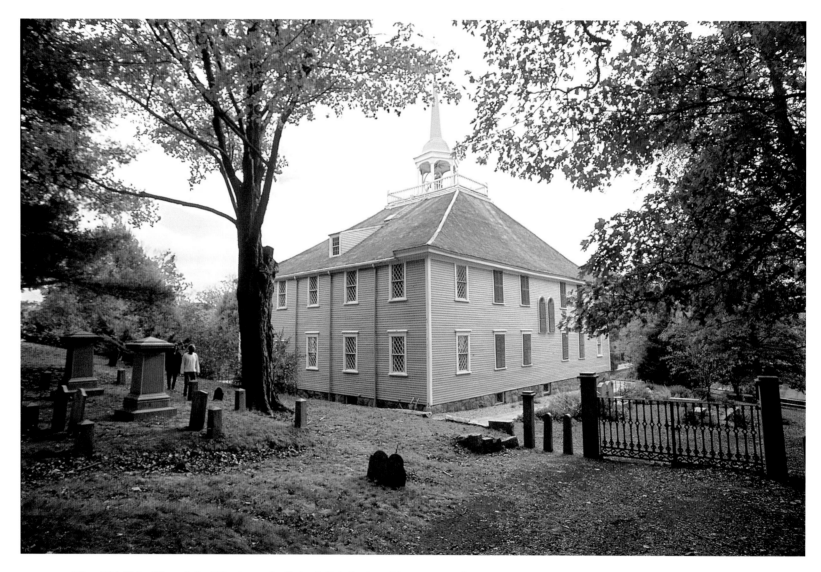

The Old Ship Church in Hingham, built in 1681, is the oldest meetinghouse in continuous ecclesiastical use in the country. Its tradition of liberal theology began with Rev. Ebenezer Gay, whose ministry spanned much of the eighteenth century. Officially known as First Parish Hingham, Unitarian Universalist, the Old Ship took its nickname from the massive roof beams believed hewn by ship's carpenters. In the foreground is Hingham Cemetery, a "garden" cemetery modeled after Cambridge's Mount Auburn Cemetery.

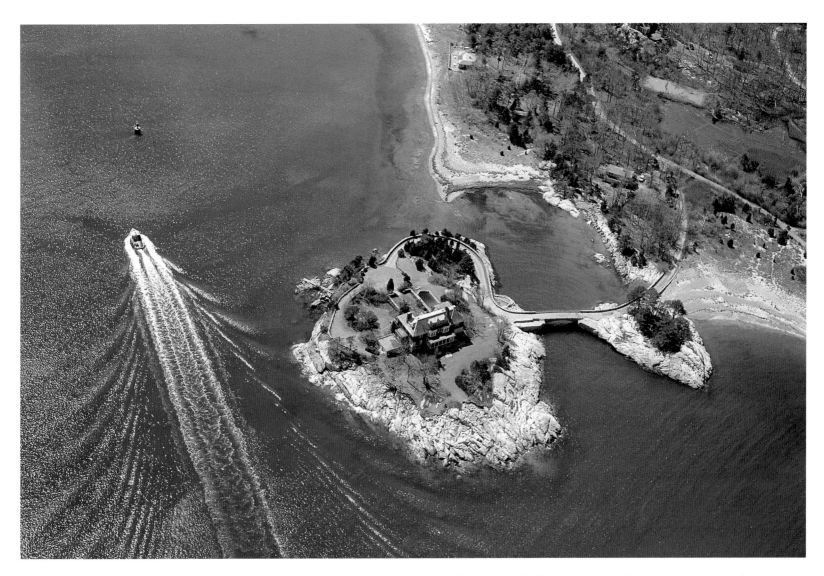

After a day hauling traps, a lobster boat steams into Cohasset Harbor past Whitehead Point. On his way to Cape Cod in October 1849, Henry David Thoreau stopped here to see the aftermath of the storm-caused wreck of the *St. John*. In *Cape Cod*, he writes, "We kept on down the shore as far as a promontory called Whitehead, that we might see more of the Cohasset Rocks. In a little cove . . . there were an old man and his son collecting, with their team, the sea-weed which that fatal storm had cast up, as serenely employed as if there had never been a wreck in the world."

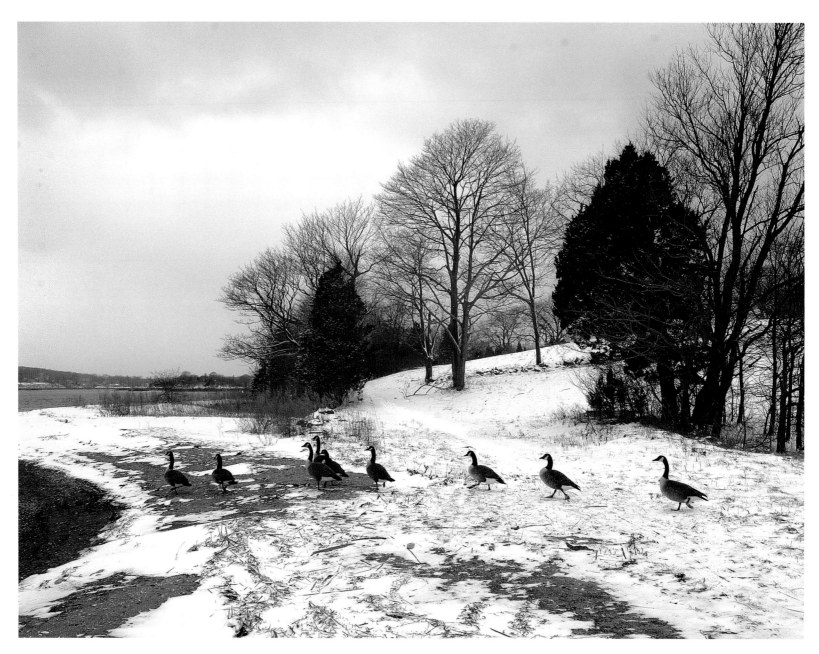

Canada geese meander down to the water's edge at World's End in Hingham. The glacial drumlins of World's End, a stunning 250-acre property managed by The Trustees of Reservations, jut out into Hingham Harbor. During the 1880s, four miles of carriage paths (designed by Frederick Law Olmsted) and three miles of footpaths provide breathtaking views and take walkers to meadow, marsh, shore, woodlands, and rocky outcroppings.

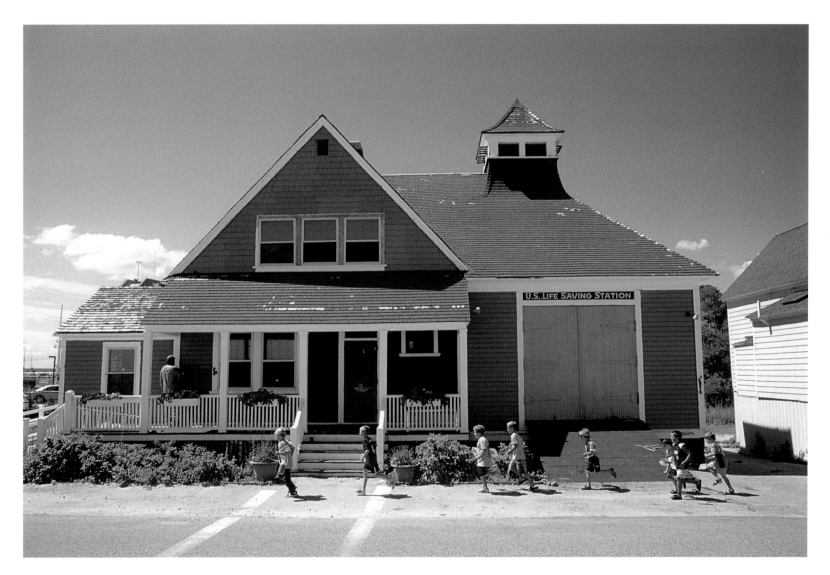

Children enjoy a summer day at the Hull Lifesaving Museum, once a U.S. Lifesaving Service station, in the Point Allerton neighborhood of Hull. One of Hull's five "eminences"—hills—Point Allerton was the spot past which all vessels entering Boston Harbor sailed. In 1889, the Lifesaving Service built a station here and appointed the celebrated lifesaver (and Hull native) Joshua James the station's first keeper. Among the items on display at the museum is equipment used by James and his heroic crew—Lyle gun, breeches buoy, surfboats, and lanterns.

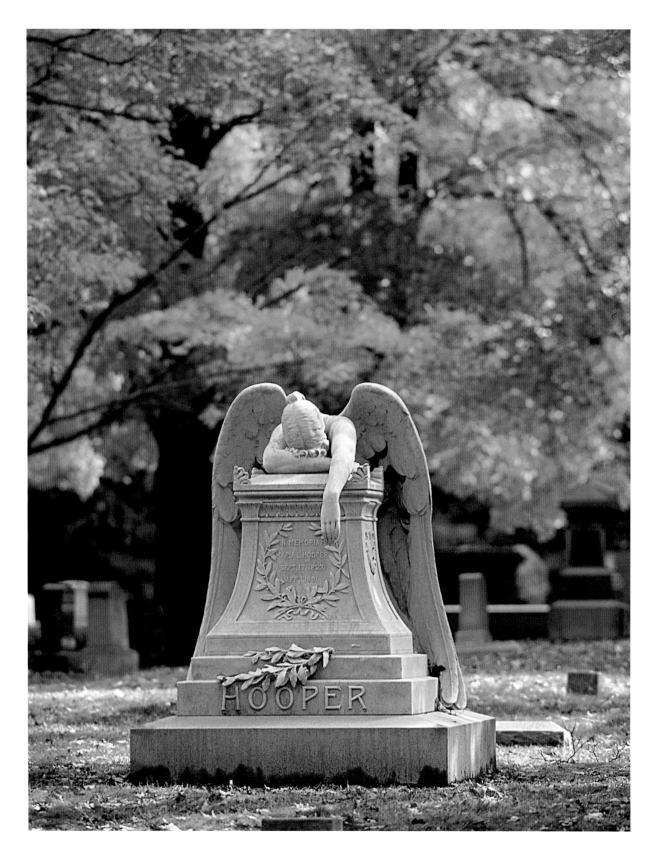

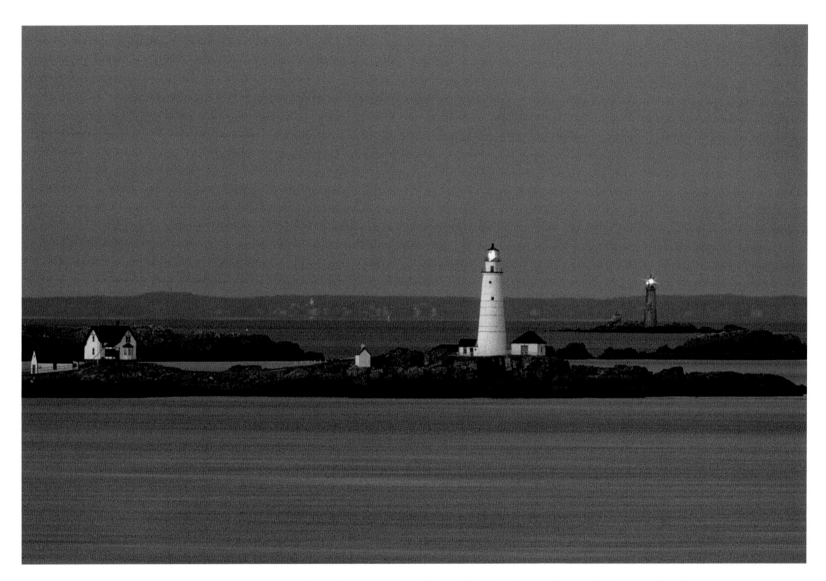

Seen from the Hull shore, Boston Light and Graves Light (left and right, above), glow at dusk several miles apart. Situated at the outer edge of Boston Harbor on the ledges known as The Graves, Graves Light was first lighted on September 1, 1905, to mark a new shipping channel into Boston's Inner Harbor. Constructed of granite blocks on a treacherous rock ledge, the 113-foot tower is considered a marvel of lighthouse engineering.

In Hingham Cemetery (left), the Victorian marble sculpture *Angel of Grief* graces the grave of Maria Hooper. The memorial is a copy of one made by William Wetmore Story for his wife's grave in Rome. Among the notable Hingham residents interred in the seventeen-acre cemetery are Governors John Long and John Andrew; General Benjamin Lincoln, George Washington's second-in-command; Hingham benefactress Madame Sarah Derby; and the first three ministers of Old Ship Church.

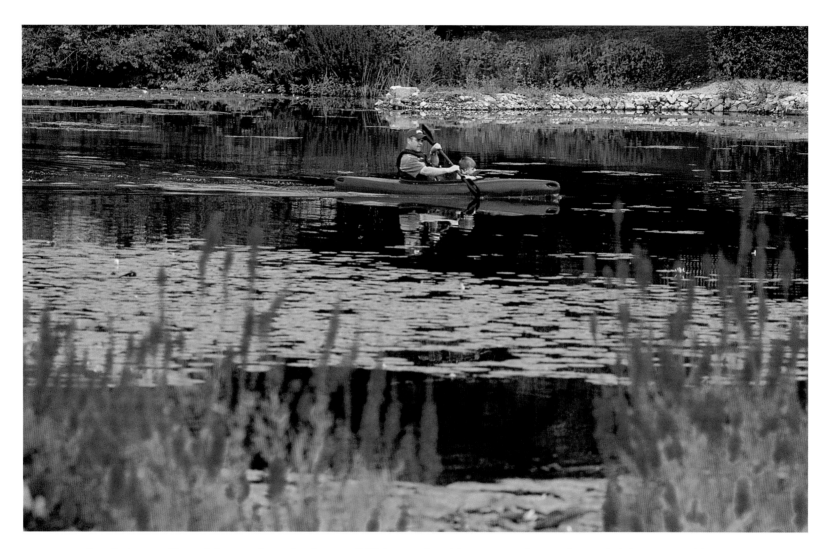

Purple loosestrife proliferates along the shores of Whitman's Pond in Weymouth. Popular with fishermen and boaters, the pond serves as the town's secondary drinking water supply and as the ancestral home for spawning herring. In early spring, the herring make their way from offshore into the Back River, under Commercial Square and the Iron Hill neighborhood, up the fish ladders, and finally "home" to Whitman's Pond, where they were born three or four years earlier.

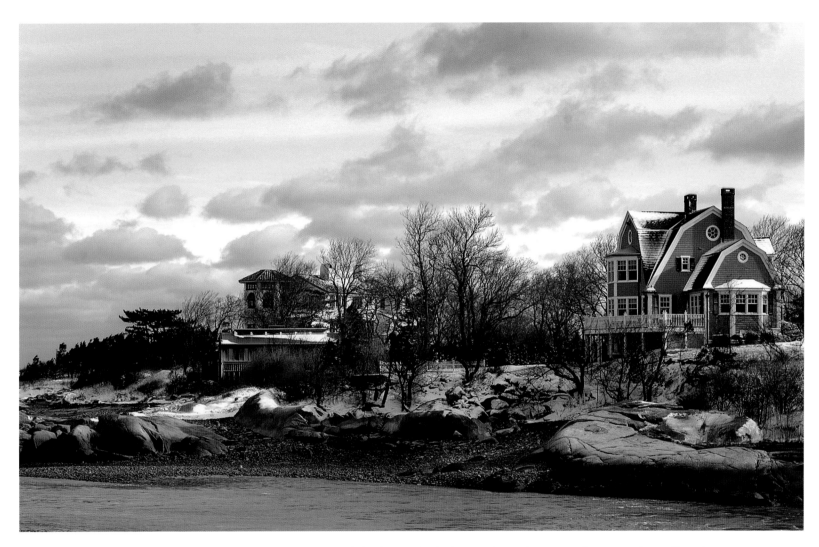

Oceanside homes in Cohasset are typical of the homes built during the early twentieth century by well-to-do vacationers who turned Cohasset into a fashionable summer resort. Thanks in part to its extensive marshland and bedrock, Cohasset has been able to retain its open space and small-town charm.

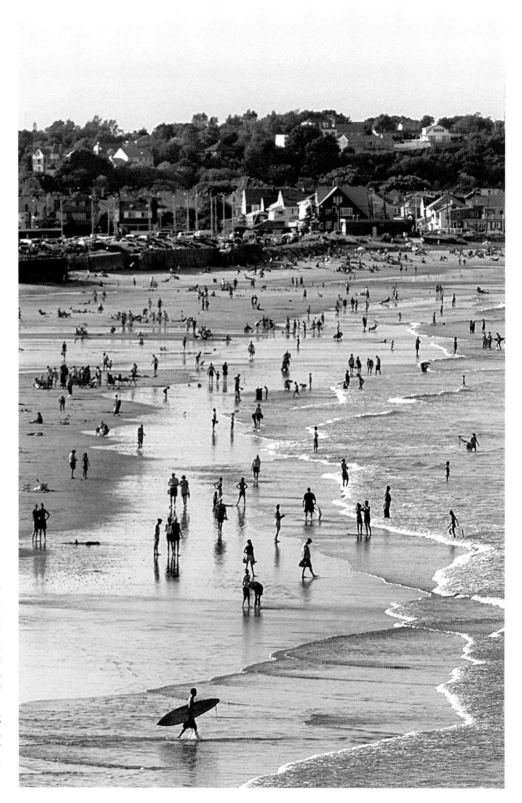

With fine sand and a gentle grade, Hull's 26-acre Nantasket Beach Reservation is a mecca for sun and sand lovers of all ages. In the mid-1800s, grand hotels offering music, dancing, and billiards lined the beach, and by the early 1900s Paragon Park was one of the East Coast's premier amusement parks. Today the Hull seaside is undergoing a renaissance, with new restaurants, boutiques, and luxury ocean-view hotels and condominiums.

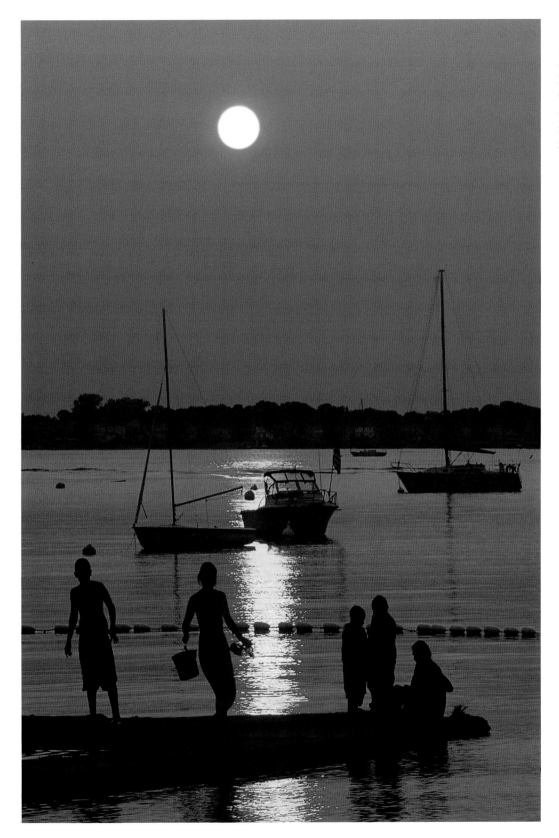

Children enjoy a late summer afternoon at Wessagussett Beach in Weymouth, which carries the town's Native American name. The town was renamed in 1635 after one hundred settlers arrived from Weymouth in England.

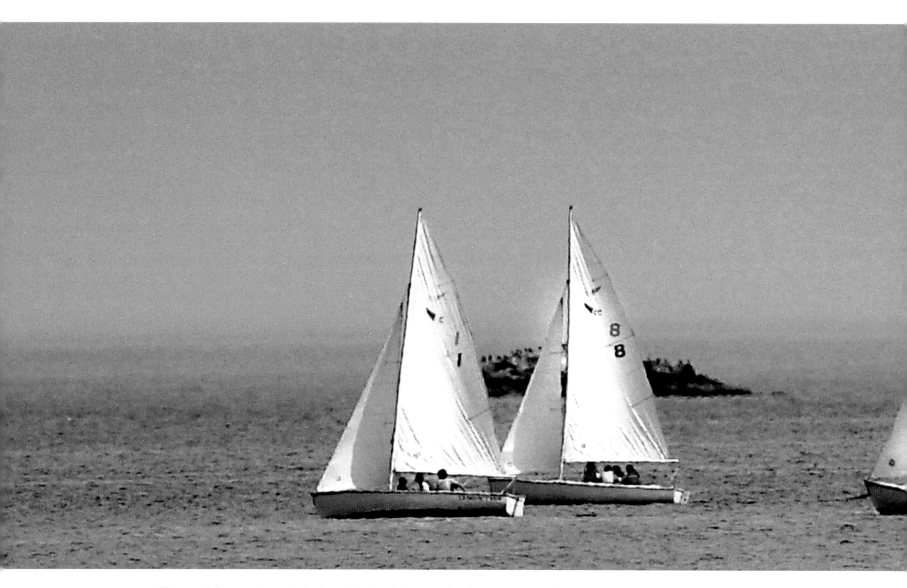

Sailboats glide past Minot's Ledge Light in Cohasset, the day's serenity belying the treachery of the Quonahasset Rocks, a legendary ship's graveyard. After dozens of offshore shipwrecks, a lighthouse was finally built on the ledge in 1850. A year later, it collapsed into the sea during a fierce storm, sweeping away its two keepers. A new lighthouse was built of blocks of Quincy granite specially dovetailed for added strength. Nevertheless, Minot's Ledge—now automated—was one of the most dangerous postings for a keeper.

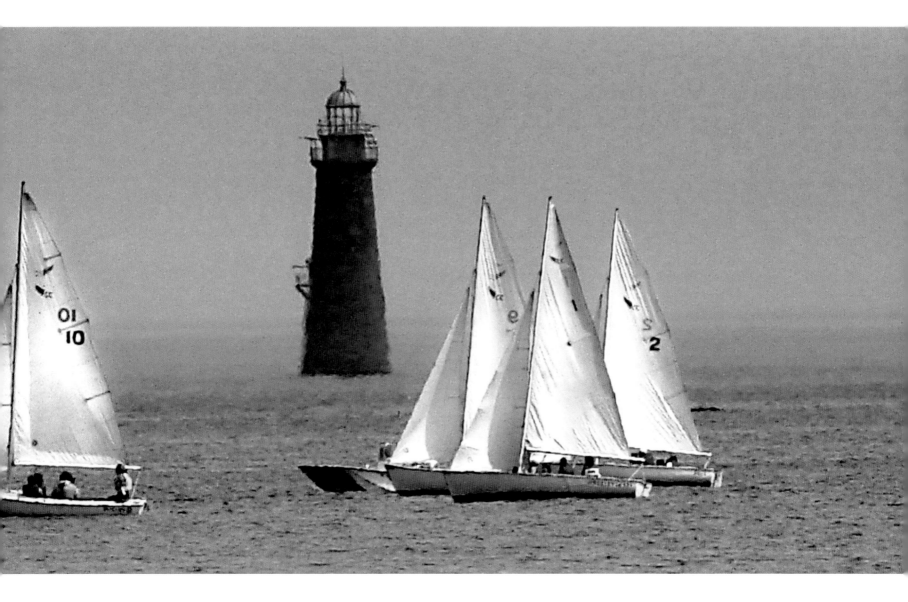

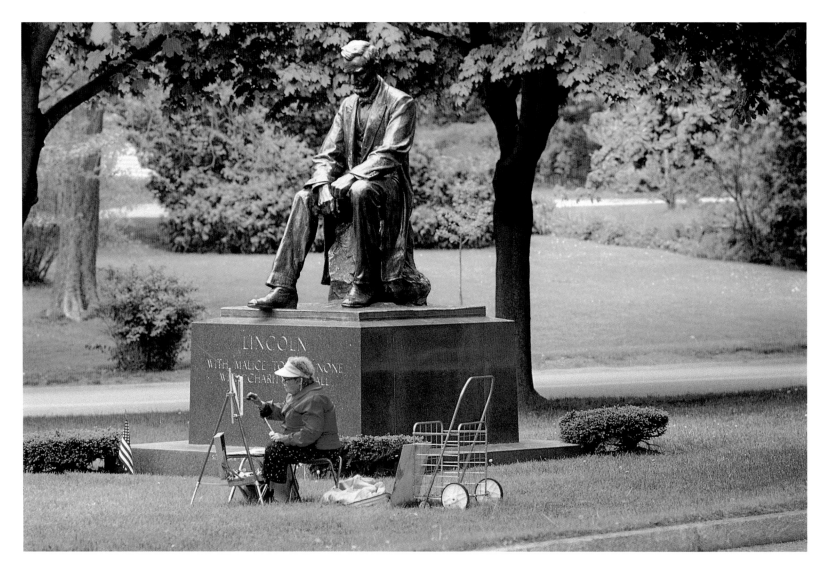

A statue of President Abraham Lincoln watches over an artist who has set up her easel on the downtown green in Hingham's Lincoln Historic District. President Lincoln has ties to Hingham, originally named Bare Cove, through his ancestor, Samuel Lincoln of Hingham, England, who settled here in 1637. The Samuel Lincoln house stands directly across the street from the Lincoln statue.

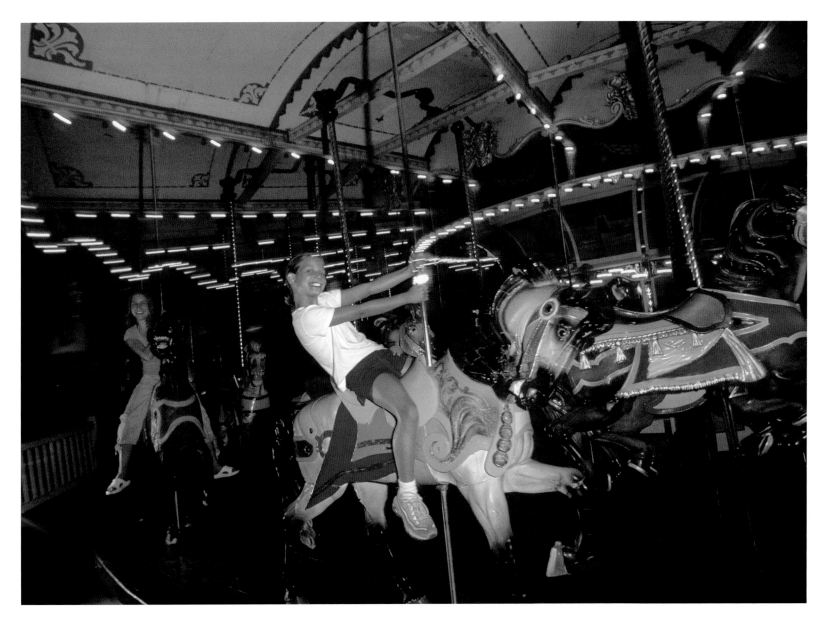

Kids enjoy a whirl on Hull's historic Paragon Park Carousel at Nantasket Beach. Surviving from a time when more than 6,000 hand-carved, wooden carousels were in operation across the country, this carousel, with its sixty-six horses and two Roman chariots, was built in 1928 by the Philadelphia Toboggan Company. After the park closed, Friends of the Paragon Carousel purchased the historic merry-go-round for $1 million to keep it in operation.

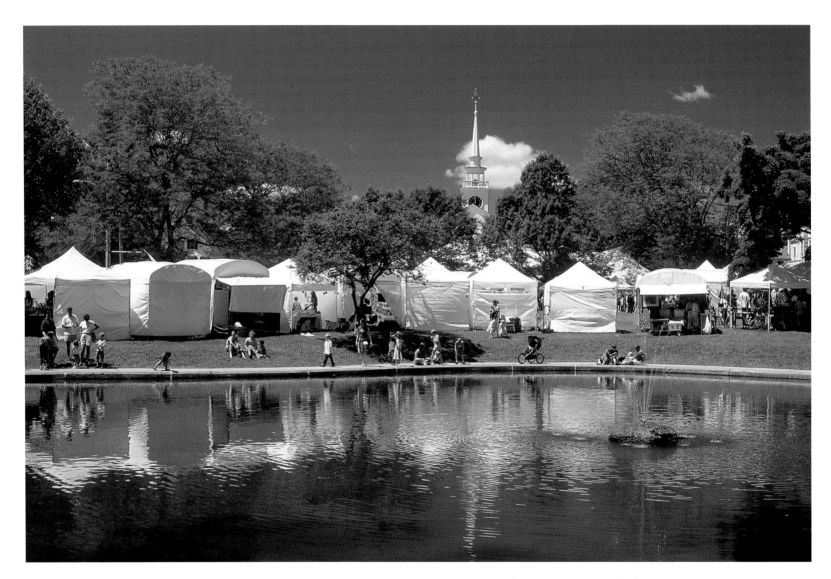

Every June since 1956, historic Cohasset Common (above) has been transformed by the South Shore Arts Festival,
a weekend-long, open-air art gallery where hundreds of local artists and artisans display their work.

On Government Island in Cohasset (right), the shore station
where Minot Light's keepers once resided, a replica of Minot
Light's lantern room—housing an original Fresnel lens—is
as close as most folks will ever get to the lighthouse.

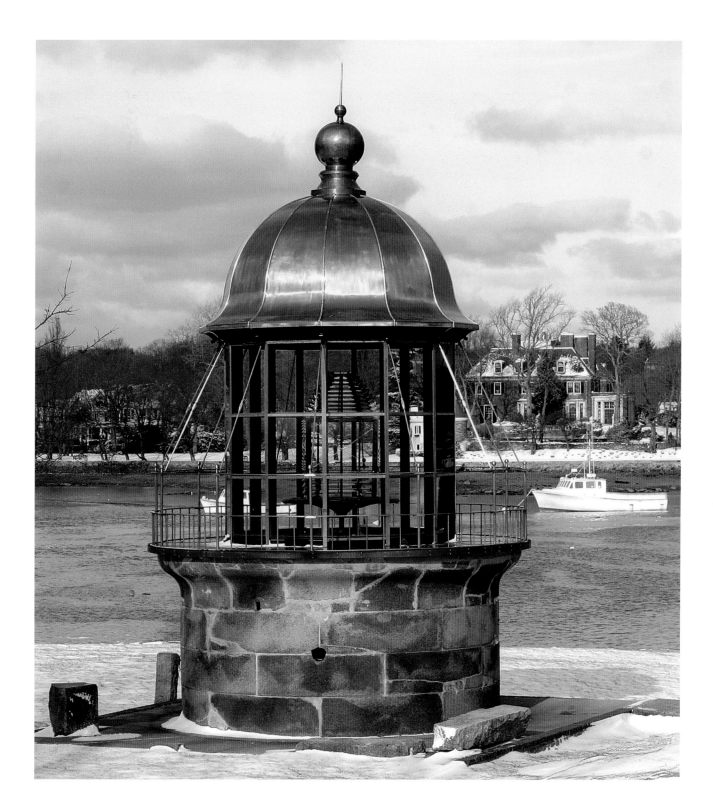

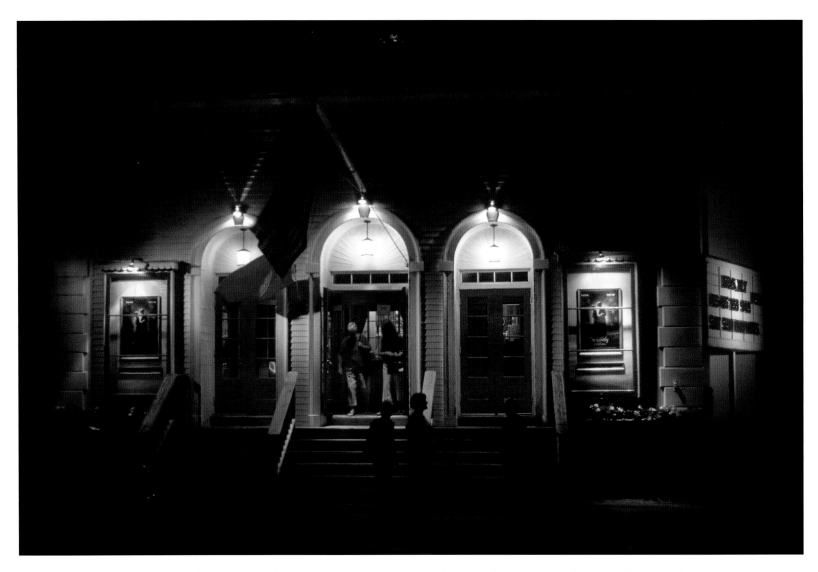

Hingham's Loring Hall Cinema, in historic downtown, is a throwback to the quaint single-screen theaters of yesteryear. Named for town-born Colonel Benjamin Loring, who spearheaded the effort to build a commodious lyceum suitable for lectures and social meetings, Loring Hall was dedicated in October 1852. Among the nineteenth-century intellectuals who lectured here were Ralph Waldo Emerson and Oliver Wendell Holmes. The hall has been a movie theater since 1936.

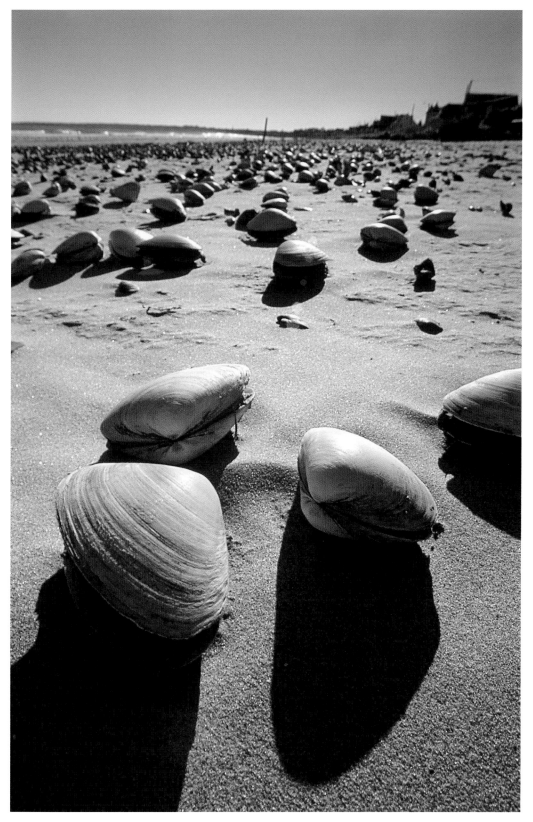

Almost as plentiful as sunbathers on Hull's Nantasket Beach on a hot summer's day are the sea clams dredged up from offshore waters during fierce storms. Fishermen and lobstermen gather the clams for bait and chowder—if they can beat the seagulls to them.

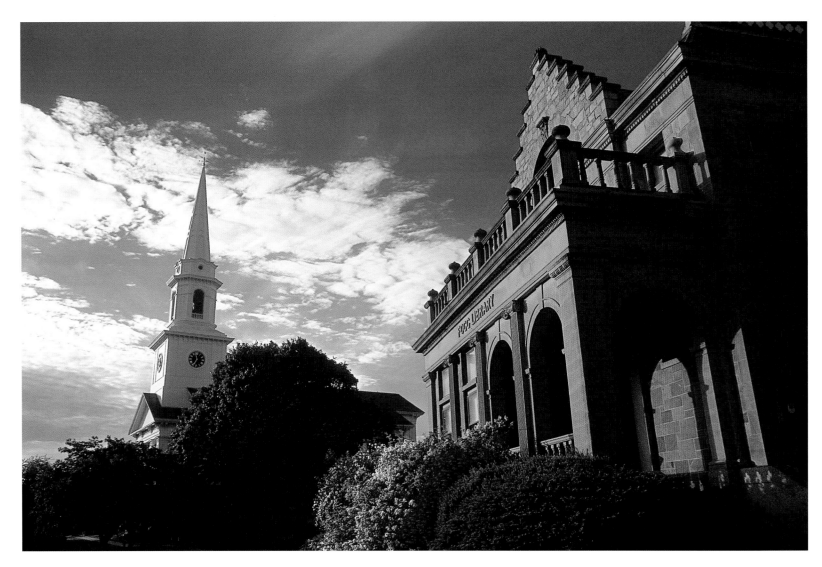

The Fogg Library and the Old South Union Church grace the busy junction of "trails" in Columbian Square,
known by the locals as "The Great Plain," one of Weymouth's four village centers. The Fogg Library,
built of Weymouth granite by the Fogg family in 1897, was Weymouth's first public library.
Next door, the Old South Union Church is an exact exterior replica
of the 1854 church that was destroyed by fire in 1989.

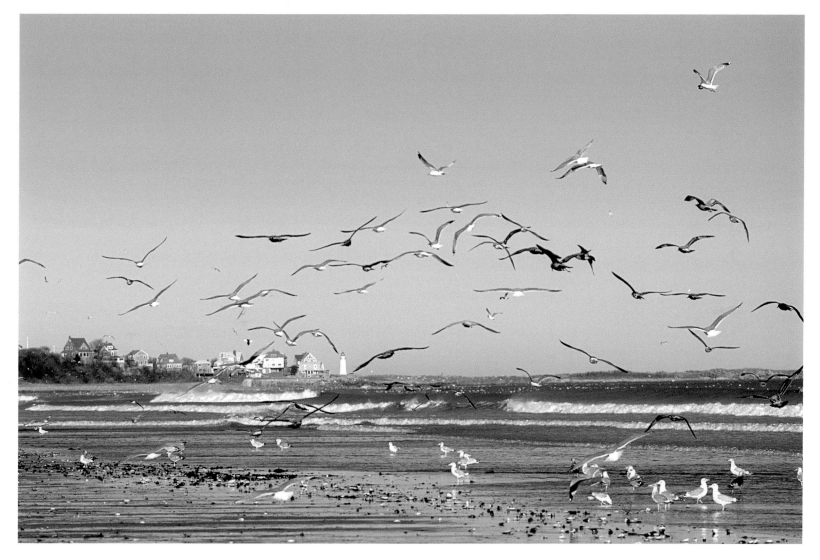

The seagulls are the first to flock to Nantasket Beach after a storm to pick over the "goodies" washed ashore. For them, it's gourmet dining at its best. Boston Light—a local as well as a national landmark—sits regally in the distance.

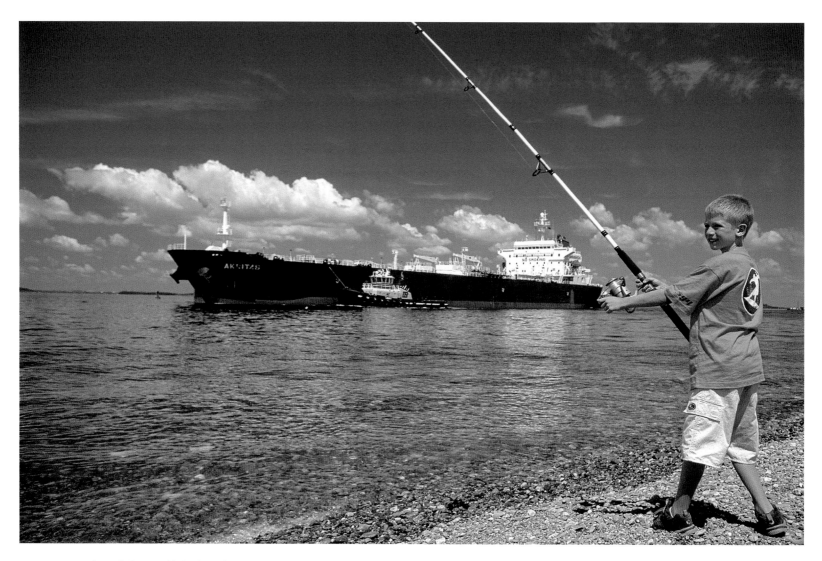

A boy fishing off the beach at Windmill Point hopes for a striped bass the size of the tanker passing through Hull Gut's churning waters. The Gut—meaning narrow passage—lies between Hull's Windmill Point and Peddocks Island. It is a shipping lane used by vessels steaming in from Boston's Outer Harbor to Quincy's Fore River.

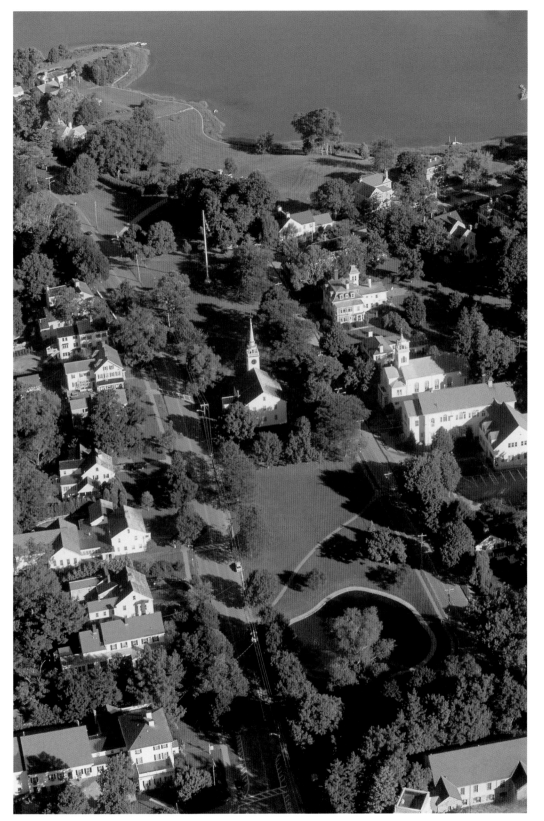

An aerial view of Cohasset
shows it to be the quintessential
picture-postcard New England
village. The centerpiece of the
Common and the National
Historic District is the elegant
First Parish Church, established
in 1721. The present meeting-
house, dating from the mid-
1700s, is one of the oldest
churches in continuous use
in the country.

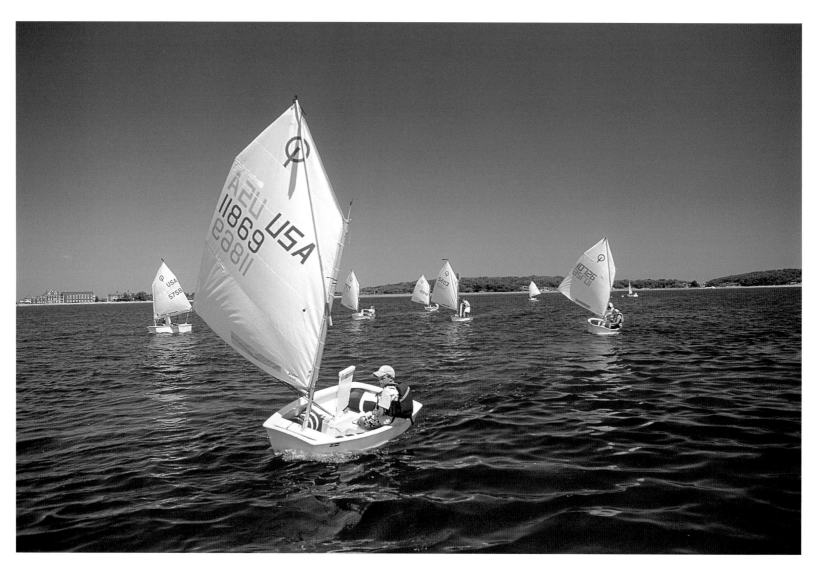

Junior sailors from the Cohasset Yacht Club enjoy a summer day racing Optimists ("Optis") on beautiful Cohasset Harbor. Founded in 1894, the yacht club's mission then and now is to "encourage yachting through the promotion of good fellowship among those interested in sailing, seamanship and enjoyment of the ocean and its environment." The club has hosted many local, regional, and national races over the years.

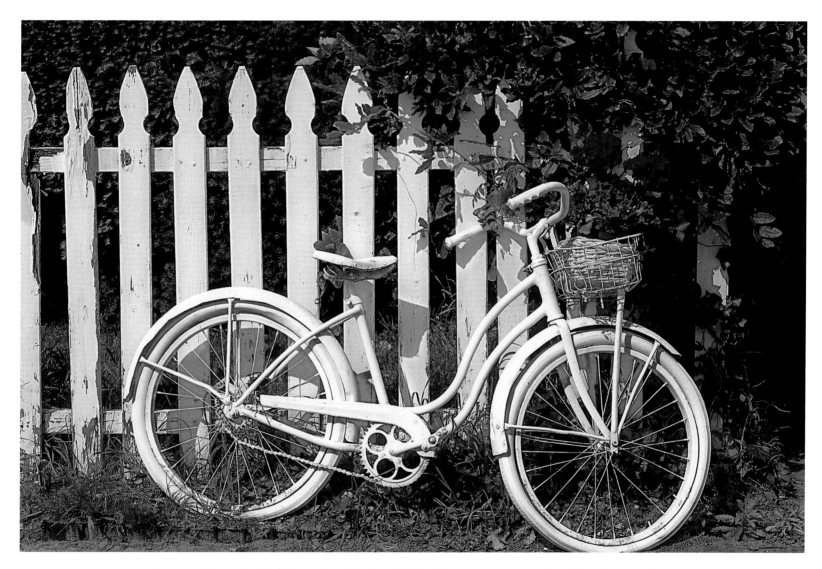

White on white: An old bike with its basket filled with geraniums waits by a fence for its rider on Samoset Avenue in Hull. With automobile parking spaces at a premium during the summer months, a two-wheeler is the way to travel.

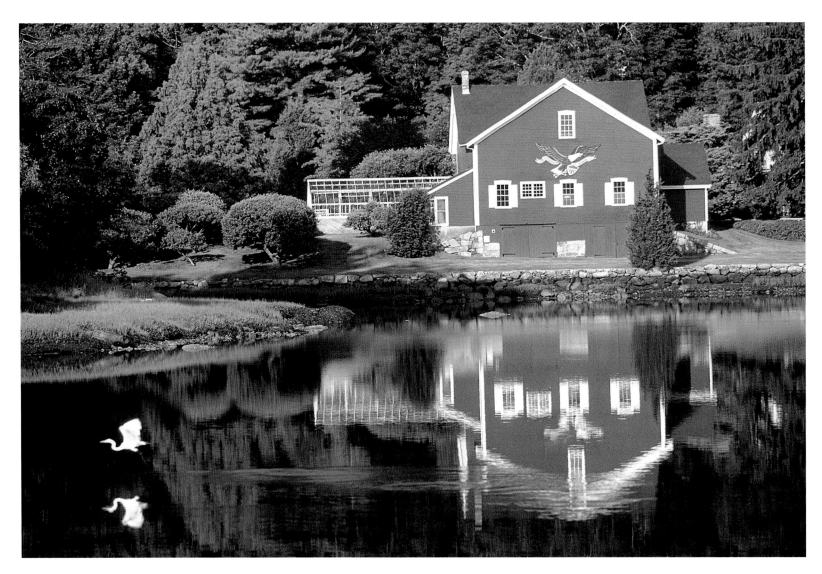

Mirror image: The Mill River in Cohasset has barely a ruffle as it reflects a lovely home and a great egret on the wing.

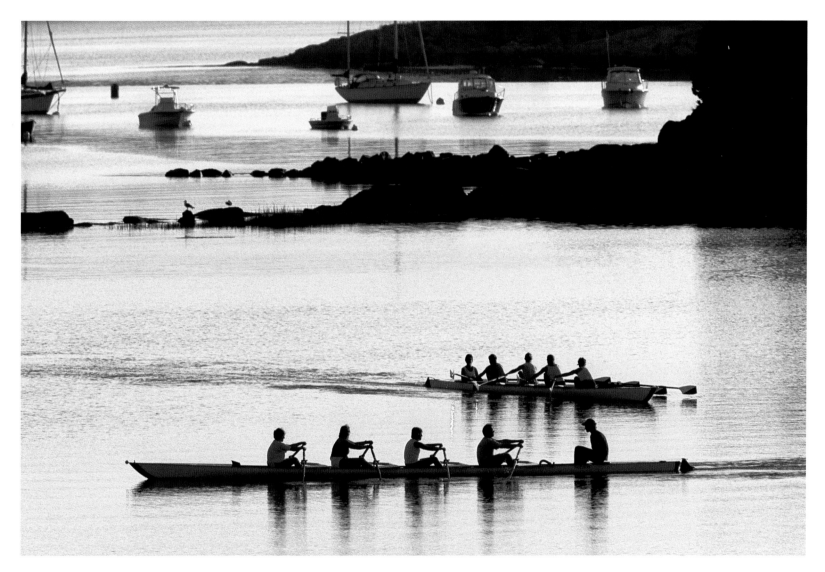

Members of the Lincoln Maritime Center rowing program depend on the steering skills of the coxswain to navigate them around the islands and mussel beds of Hingham Harbor. Founded as the Lincoln Sailing Club in 1970, the center has grown steadily over the years. The rowing program was added in 2002.

NORWELL,
SCITUATE, HANOVER,
& ROCKLAND

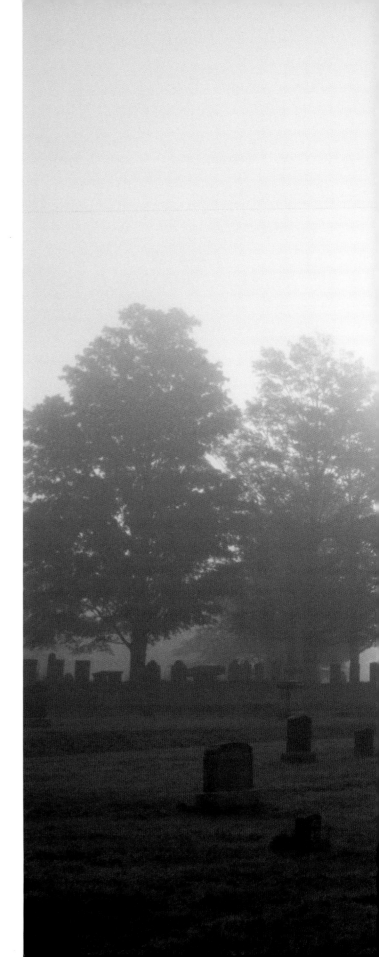

Linking the towns of Scituate, Norwell, Hanover, and Rockland is the graceful North River, winding its way twenty miles to the sea. Scituate and Norwell made their name—and national reputation— with thriving North River shipbuilding industries. Scituate, incorporated in 1636, once included the towns of Hanover and Norwell. Although landlocked Hanover and Rockland did not have access to the river, their abundant forests provided the timber that enabled North River shipyards to launch more than a thousand vessels between 1650 and 1871.

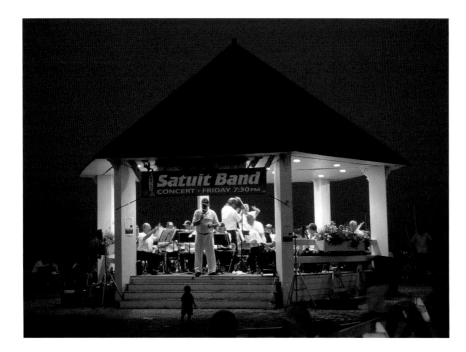

The Satuit Band performs at the Cole Parkway Bandstand in Scituate (above). Morning mist enshrouds the Hanover Center Cemetery (right).

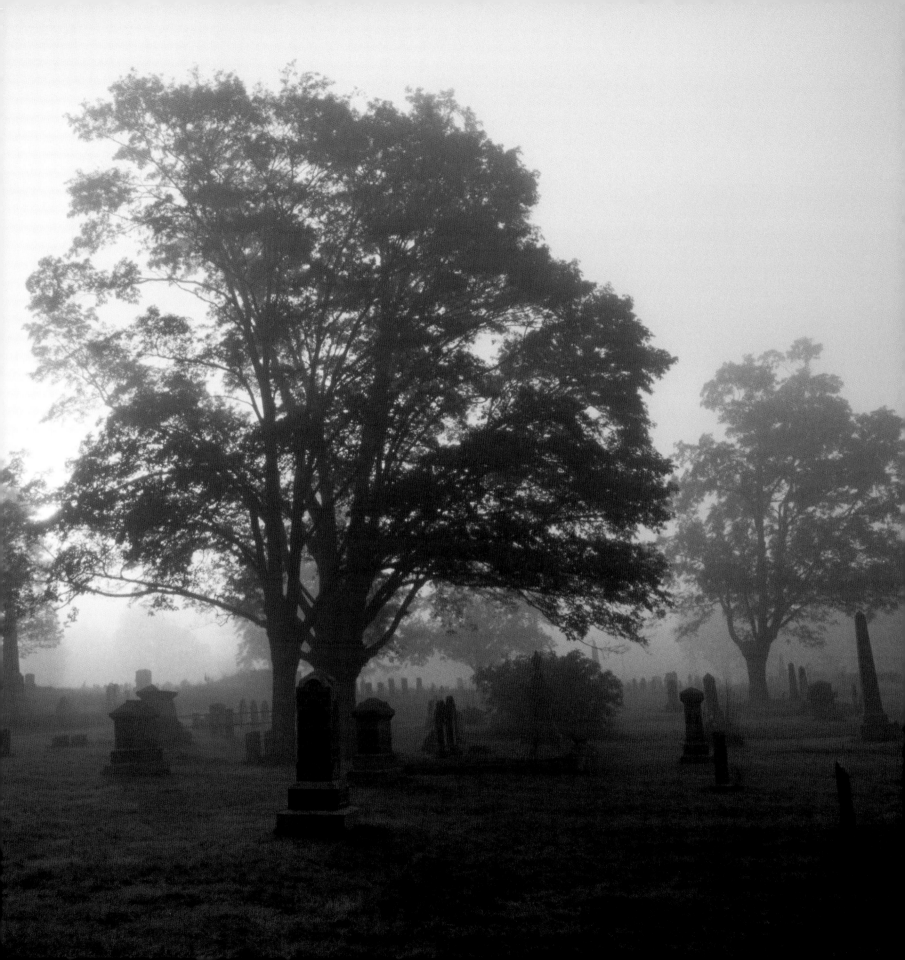

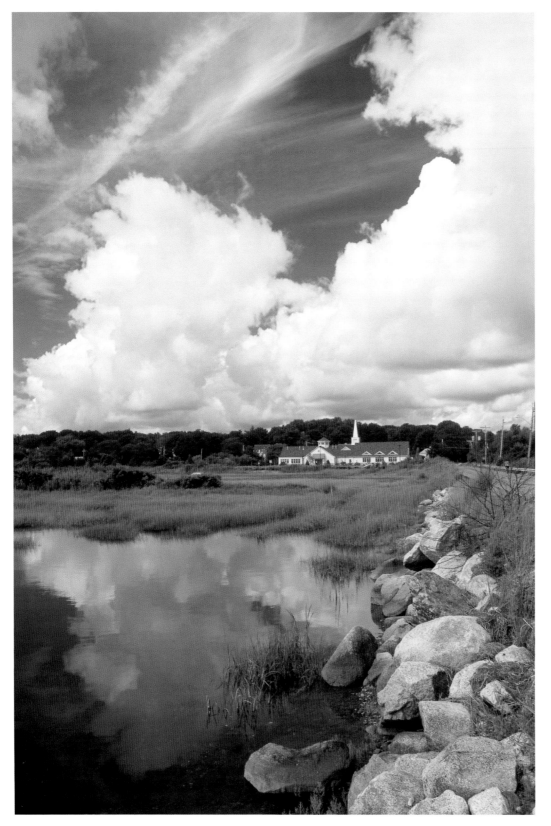

Fair-weather clouds are reflected in the still waters of a Scituate salt marsh. The natural crop of salt marsh grass was an important commodity to the English "men of Kent" who settled the town not long after the Pilgrims settled Plymouth.

The Albert F. Norris Reservation in Norwell allows even landlubbers to get up close and personal with the North River. A 117-acre property owned by The Trustees of Reservations, Norris Reservation offers nature lovers quiet ponds, a rocky stream, a forest of oak, hickory and birch, and salt marsh meadows. A walking trail meanders along the edge of the North River marsh.

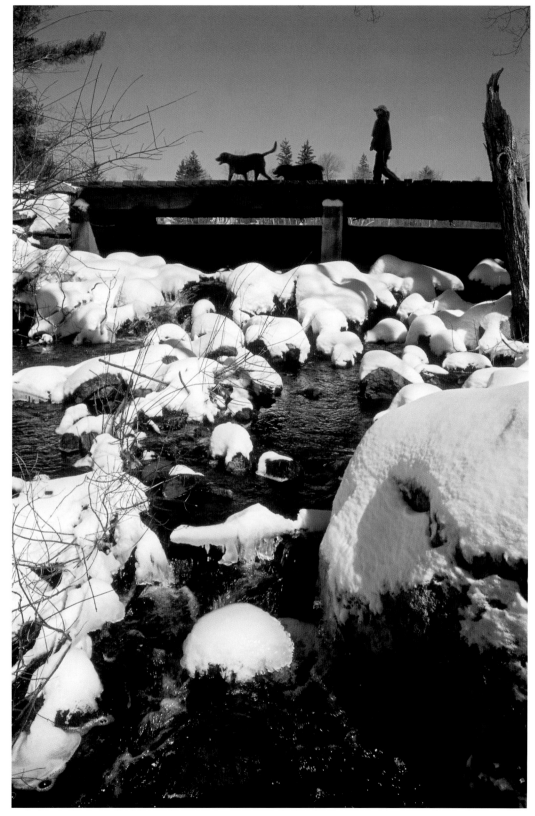

Scituate children play soccer in the shadow of the Lawson Tower. Scituate's landmark was built in 1902 by millionaire Thomas Lawson, "the Copper King," to disguise a water tower that he could see from his country estate. The 153-foot shingled tower includes a clock room and a bell room with tuned bells that are rung on special occasions.

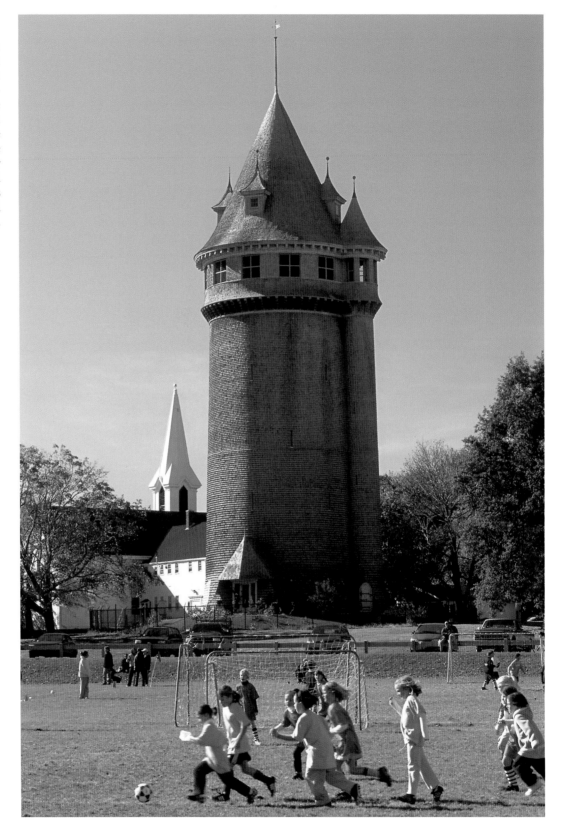

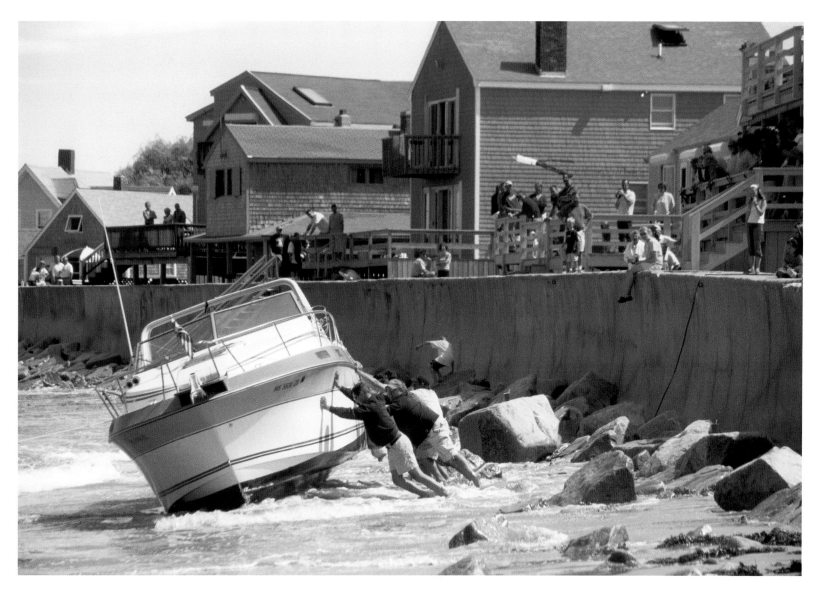

Residents in Scituate's Sand Hills neighborhood lend a hand to rescue a motorboat before it is tumbled onto the rocks. By the late 1900s, the railroad had made Scituate a popular summer destination, but the town was slow to grow until the automobile and better roads made it more accessible from Boston. Scituate still attracts "summer people" who enjoy the town's many public beaches, its excellent fishing and pleasure boating, and its commitment to its maritime heritage.

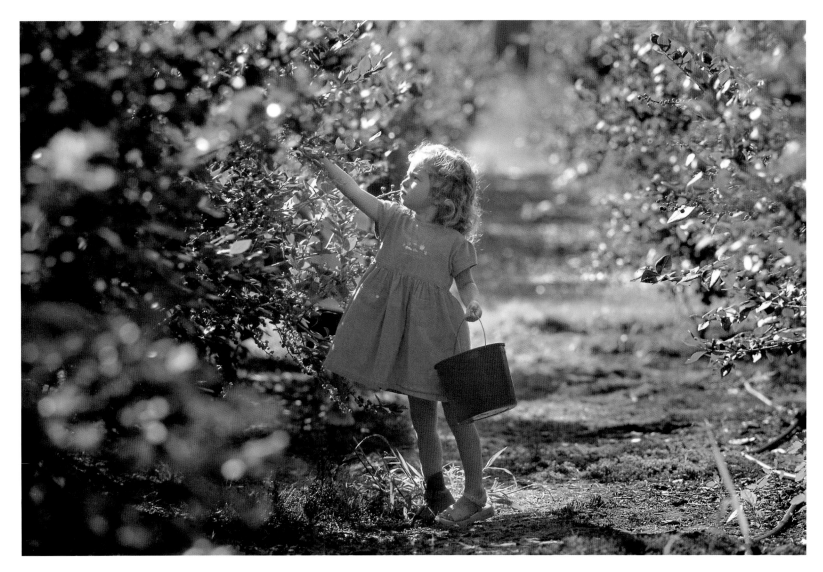

Children are welcome at Tree-Berry Farm in Scituate, where a little girl in blue hopes to fill her bucket with juicy, sweet high-bush blueberries. The "pick-it-yourself" farm, on the Scituate-Norwell border, has been farmed by the same family for four generations. The picking of high-bush blueberries begins in July and continues through September.
In November customers are invited to tag and cut their own fresh Christmas trees.

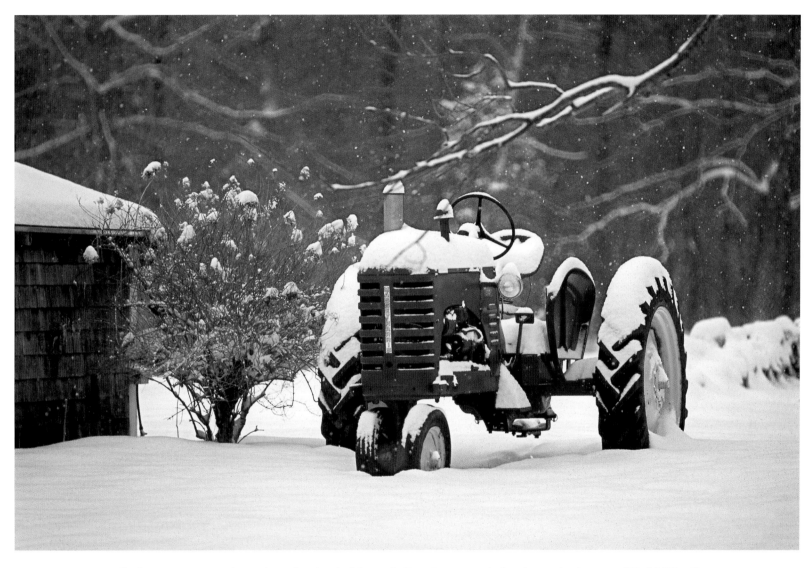

An idle farm tractor awaits spring planting in Norwell. Despite a population boom in the post–World War II era, Norwell—originally part of Scituate—still retains a rural charm.

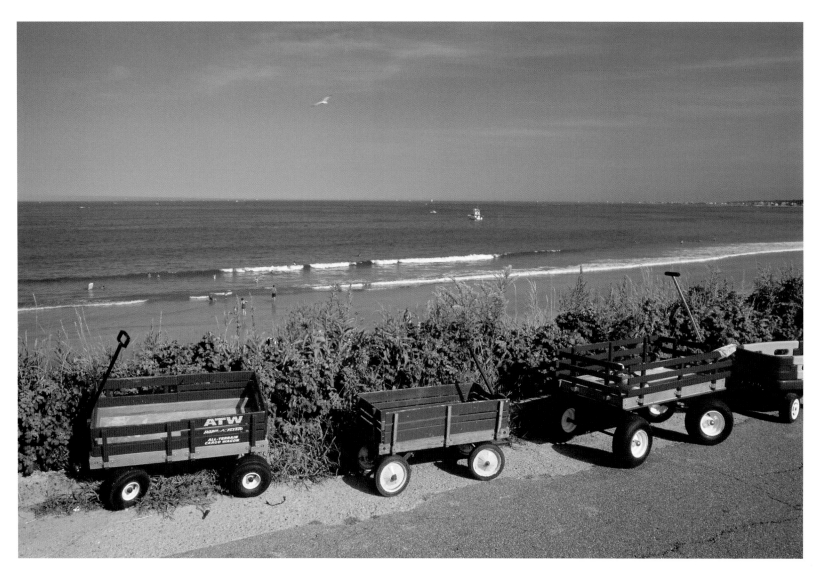

There's plenty of parking at Scituate's Gannett Beach for the red wagons that transport beach toys and beach chairs from the surrounding neighborhood.

Repainted in the 1990s in bright yellows and reds, this charming house in Rockland's Union Street Historic District is an eye-catching sight. Rockland's abundant forests once supplied North River shipbuilders with timber. As shipbuilding waned in the nineteenth century, shoe manufacturing brought a renaissance. Fortunes were made and elegant Victorian homes, several now on the National Register of Historic Places, were built.

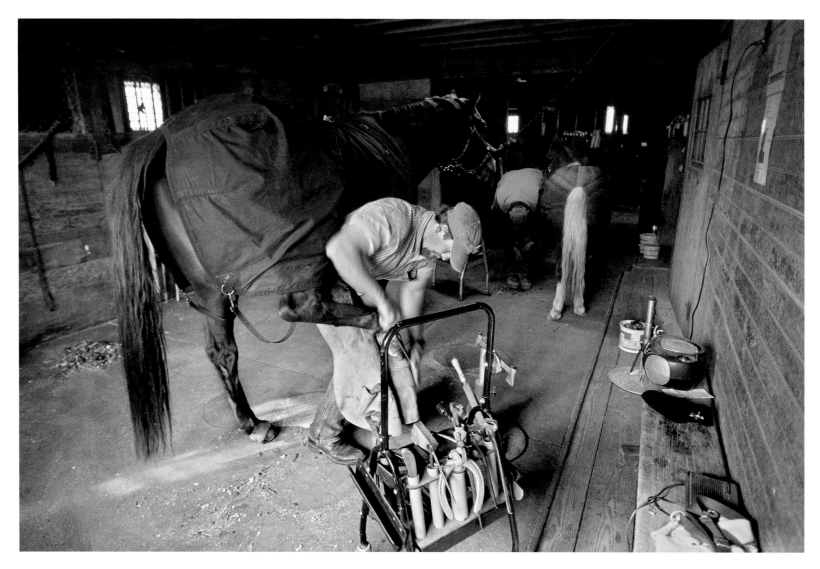

A farrier outfits a horse with new shoes at Briggs Stable in Hanover. Briggs began as a boarding stable during the 1920s and is now home to more than seventy horses.

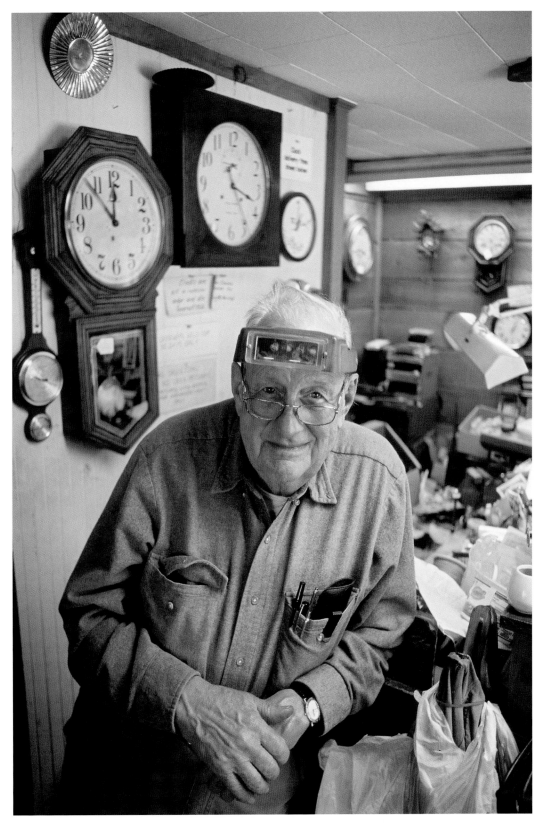

On First Parish Road in
Scituate, Irving Versoy of
Greenhouse Antiques special-
izes in clock repair.

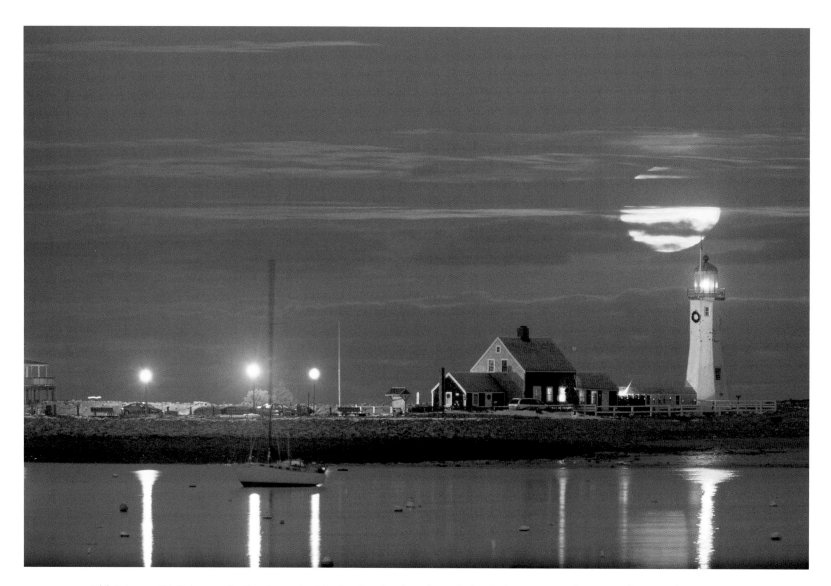

Old Scituate Lighthouse, built of granite blocks, is a landmark at Cedar Point. During the War of 1812, the year after the beacon was first lighted, the lighthouse keeper's daughters, Abigail and Rebecca Bates, saw British soldiers coming ashore. With no time to alert townspeople, this "army of two" quickly began playing military tunes on fife and drum. Fooled into thinking U.S. soldiers were in the area, the British quickly retreated to their ship. The Bates girls were credited with saving the town of Scituate. Deactivated in 1860, the lighthouse was purchased by the Scituate Historical Society in 1968 and, in 1994, relighted for the first time in 134 years.

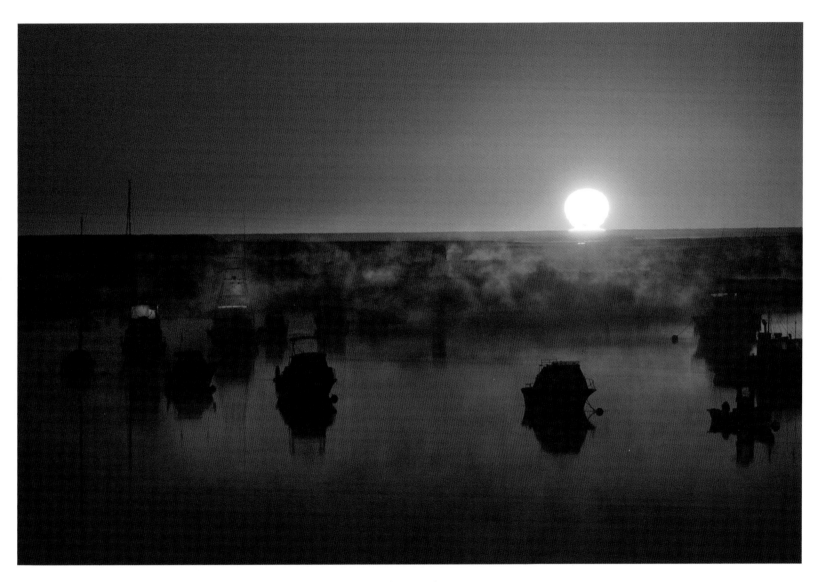

The sun rises over the North River in Scituate.

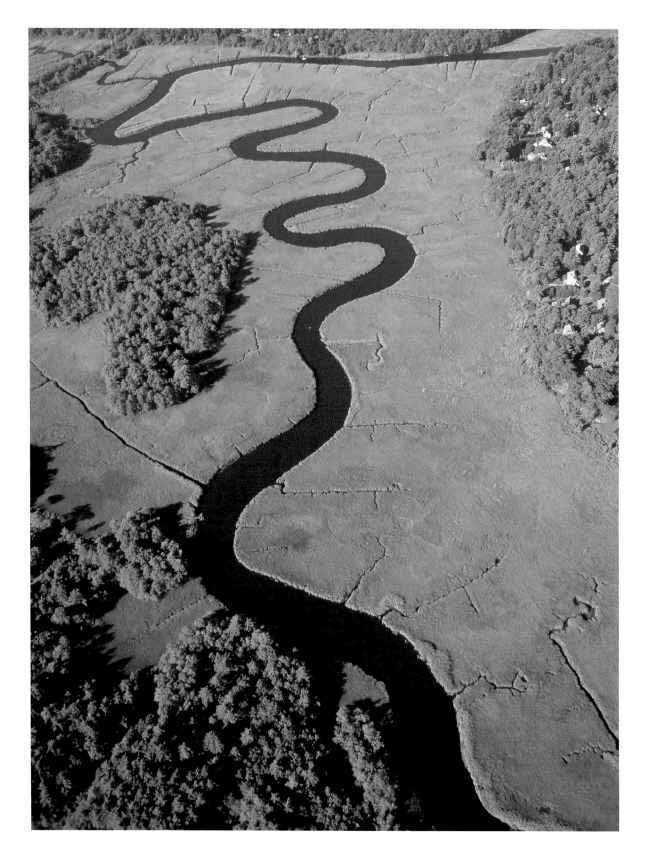

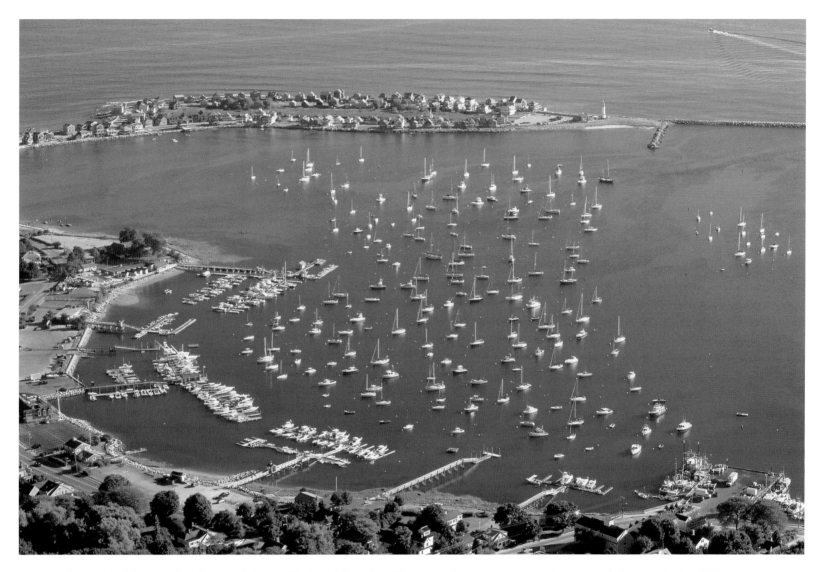

Once a thriving mackerel port, Scituate Harbor (above), midway on the coast between Boston and Plymouth, is still home to a colorful, working fishing fleet as well as a fleet of sailboats, day fishers, and whale watch excursion boats. The town celebrates its seafaring heritage every August during the Chamber of Commerce–sponsored Heritage Days.

With its broad expanses of salt marsh, the scenic North River (left) winds more than twenty miles to the sea. At one time, every bend in the river had a shipyard or landing—more than a thousand vessels were launched between 1650 and 1871. Much of the river's bordering area is a priority habitat for rare and endangered species.

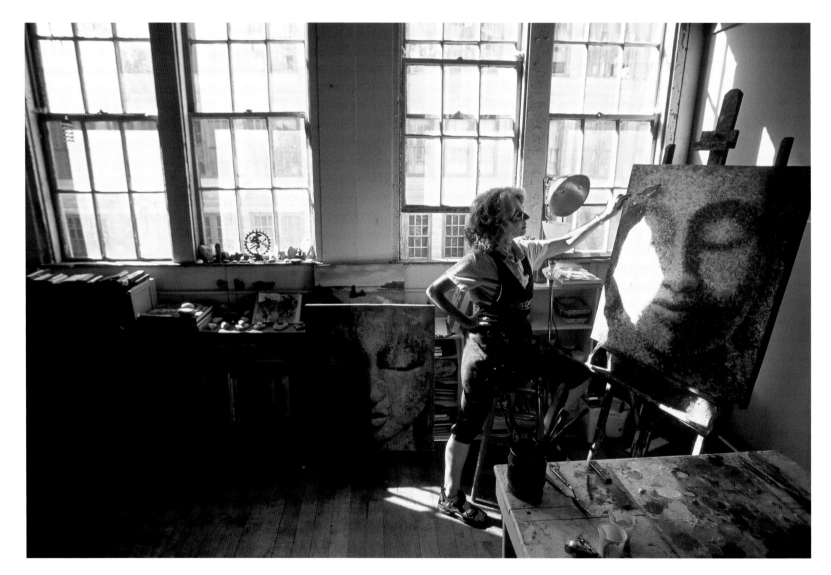

Artist Virginia Peck paints in her sunlit studio in Rockland's Codman Building, once a shoe factory, on Plain Street. Plain Street Studios now provide workspace for more than one hundred artists, the largest group of working artists on the South Shore. Until the 1930s, Rockland was one of the preeminent shoe-manufacturing centers in the country.

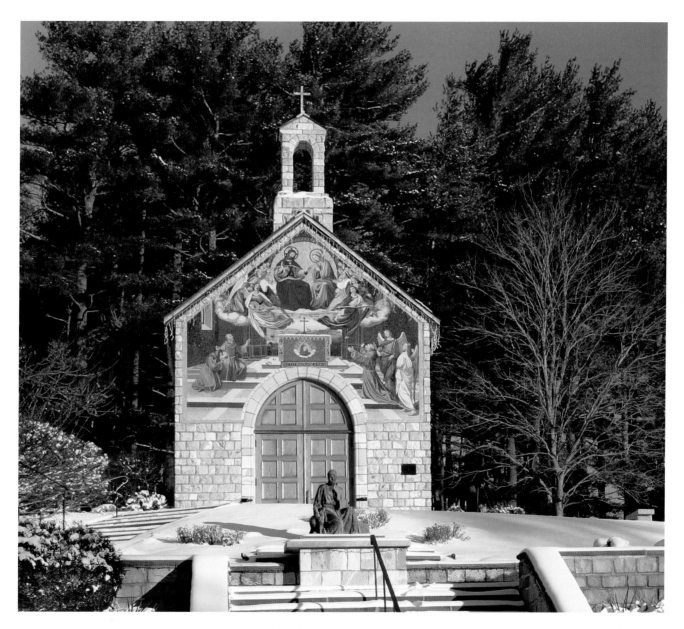

On the grounds of Hanover's Cardinal Cushing School and Training Center, a school for special-needs students, the Portiuncula Chapel is the resting place of Richard Cardinal Cushing, Archbishop of Boston from 1944 to 1970. The chapel is a replica of a thirteenth-century chapel built by St. Francis of Assisi. An eternal flame, taken from an ember in Hiroshima in 1945, burns inside the chapel, a reminder of the enduring hope for world peace.

An antique shop in the Four Corners neighborhood of Hanover is housed in one of the town's oldest homes. One of Hanover's original six villages, all of which were self-sufficient, Four Corners boasts many of the town's most historic houses and was once a stop on the stagecoach route to Boston.

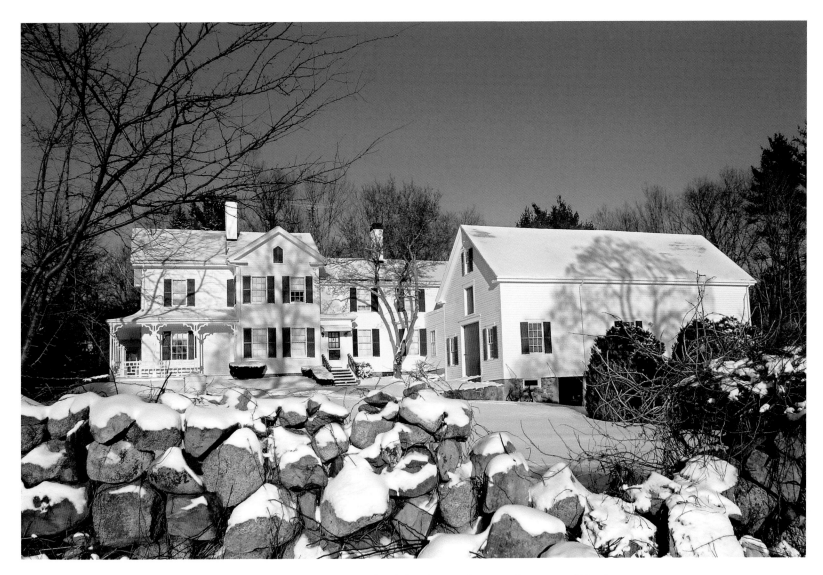

Dusted in snow, a classic New England farmhouse, barn, and stone wall in Hanover
reflect the bright sunlight of a winter's day.

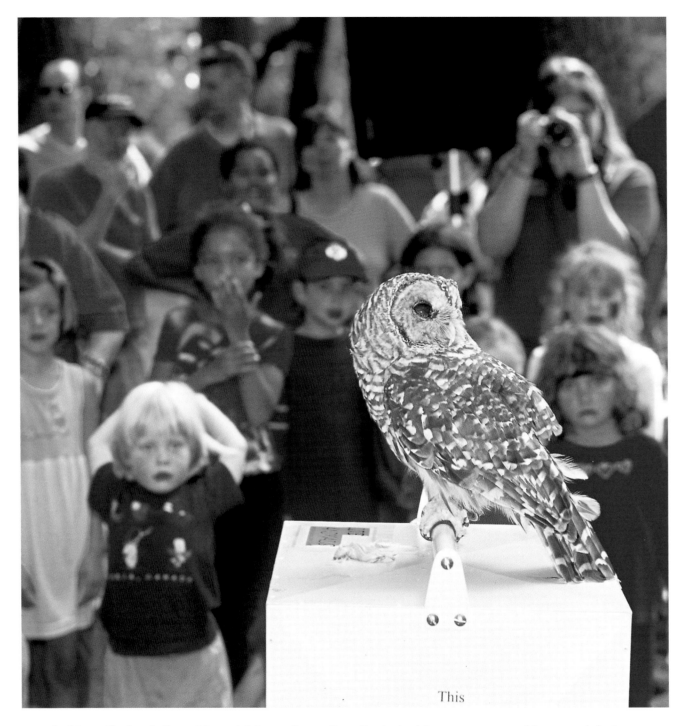

This

At Norwell's South Shore Natural Science Center Corn Festival, visitors are entranced by an owl during a live-animal demonstration. The Science Center, open year-round, is located on 30 acres and is surrounded by another 200 acres of town conservation land. Its mission is to educate the public about the natural and cultural environment of the South Shore through exhibits, live-animal programs, and seasonal festivals.

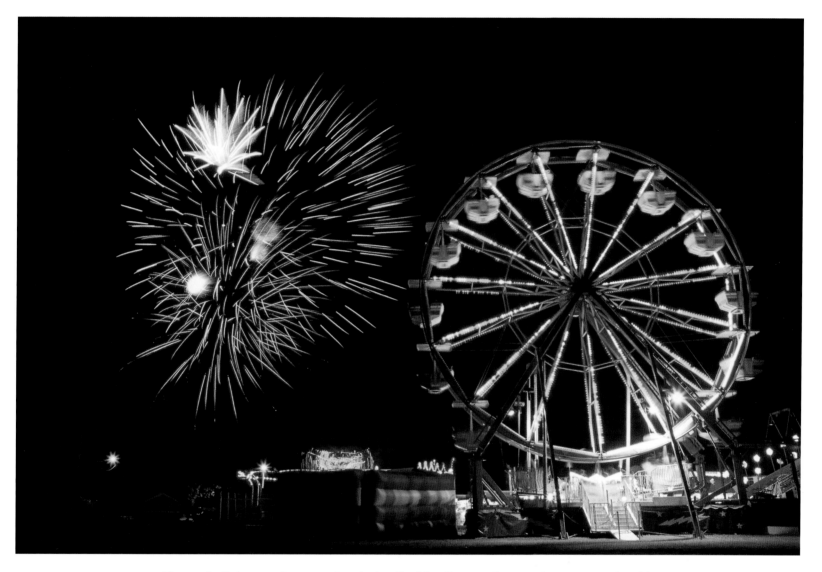

Fireworks light up a June evening during Rockland's annual carnival at Memorial Field.

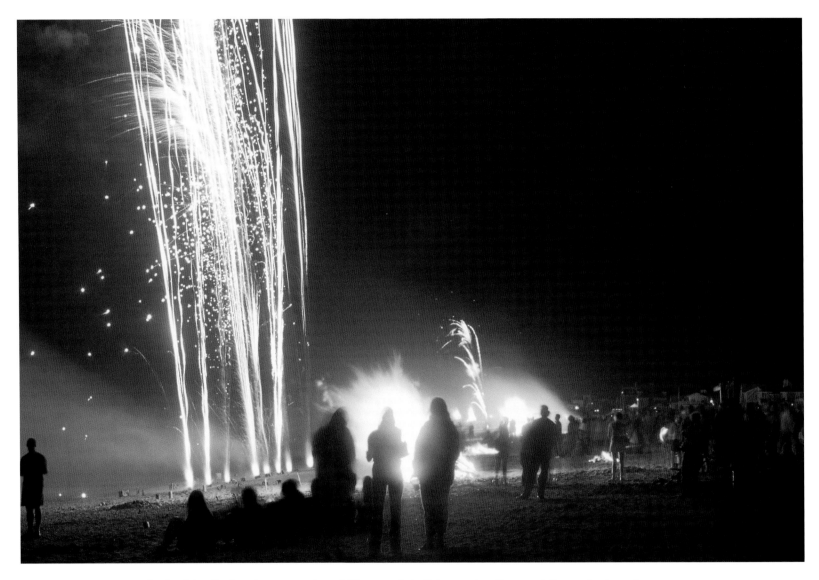

In the friendly beach community of Humarock in Scituate, bonfires and fireworks have become
a much-anticipated Fourth of July spectacle.

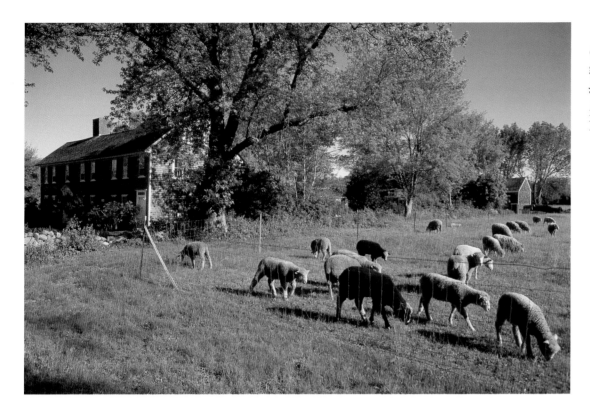

On a summer afternoon, sheep graze at the eighteenth-century Jacobs Homestead in Norwell. The town-owned farm, dating from 1726, is a reminder of Norwell's agricultural past.

In neighboring Rockland, cattle graze on Spring Street in a bucolic scene reminiscent of the last century. Despite its industrial prominence during the nineteenth century and its more recent development, large tracts of undeveloped land still exist in Rockland.

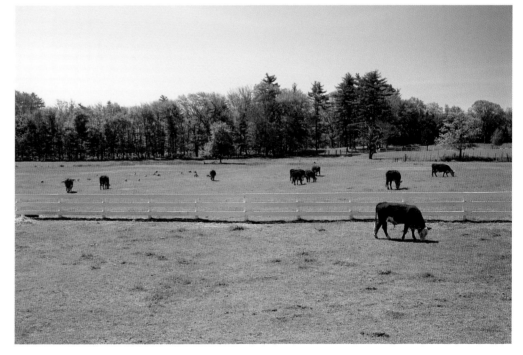

DUXBURY, MARSHFIELD, & PEMBROKE

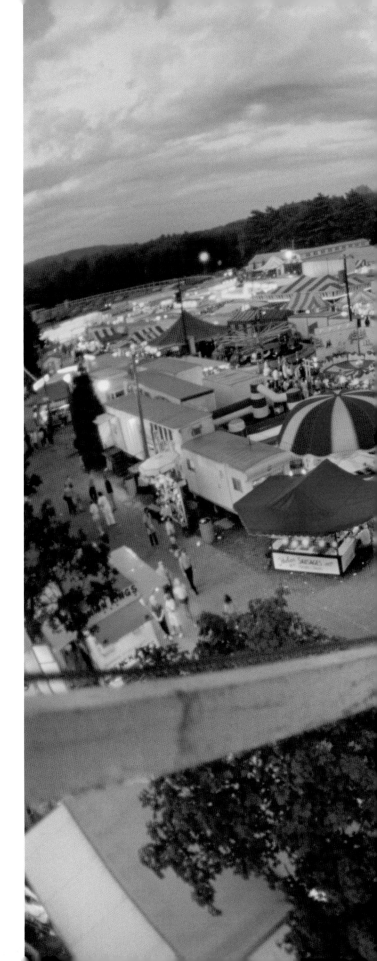

The towns of Duxbury, Marshfield, and Pembroke are linked in history by their Pilgrim roots. It was *Mayflower* passengers Myles Standish and John Alden who settled Duxbury, the second town in the Plymouth Colony, and Edward Winslow who, with a land grant from the Plymouth Colony Court, settled Marshfield. Not long after Marshfield's incorporation in 1640, Myles Standish granted land that became Pembroke.

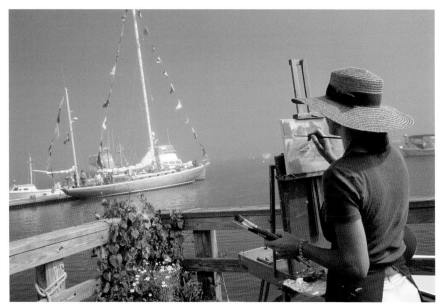

An artist finds inspiration at Duxbury's Snug Harbor (above). A Ferris wheel at the Marshfield Fair (right) affords a unique and exhilarating bird's-eye view of the town.

84

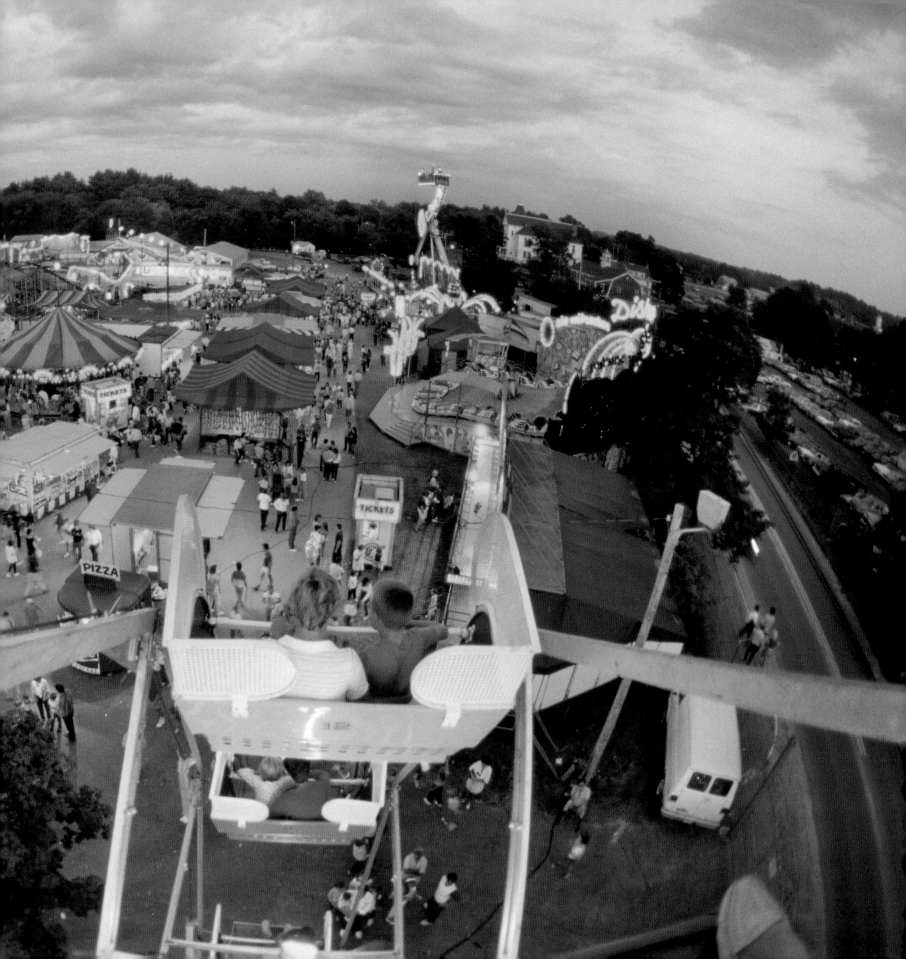

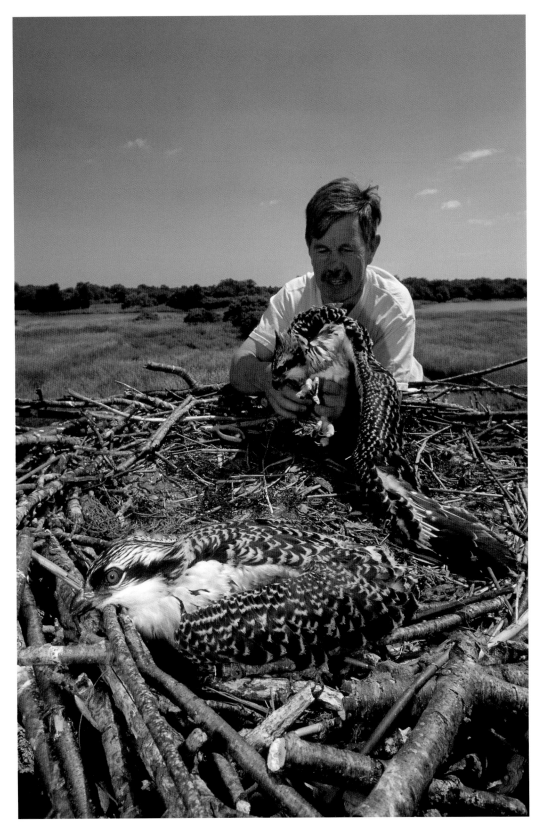

Norman Smith of the Massachusetts Audubon Society (left) bands an osprey nestling at the Daniel Webster Wildlife Sanctuary in Marshfield. The sanctuary is named for the orator-statesman who made Marshfield his home.

A young lad (right) has his hands full with a wriggling herring at Pembroke's annual Herring Run Fish Fry.

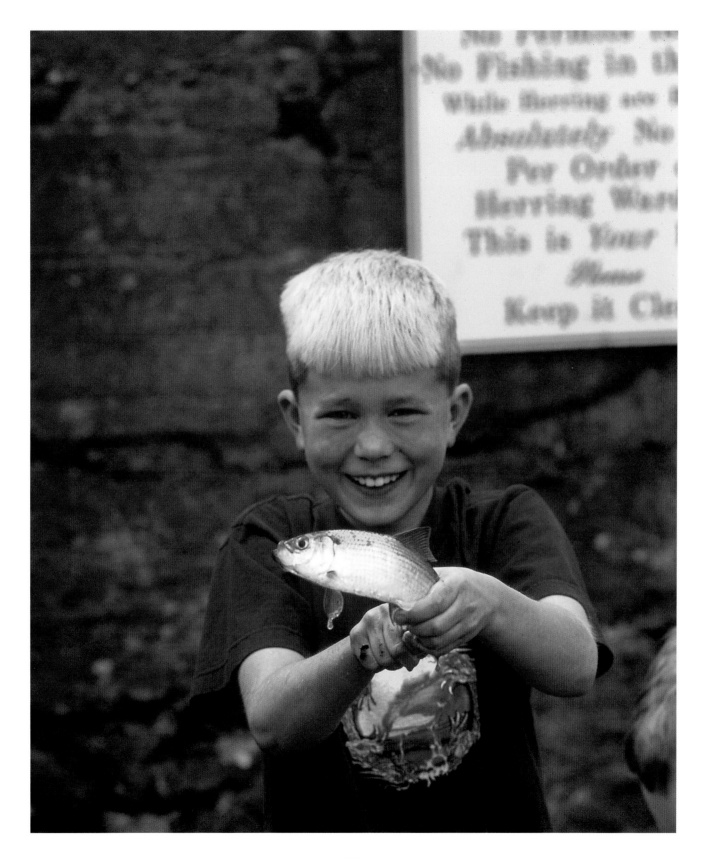

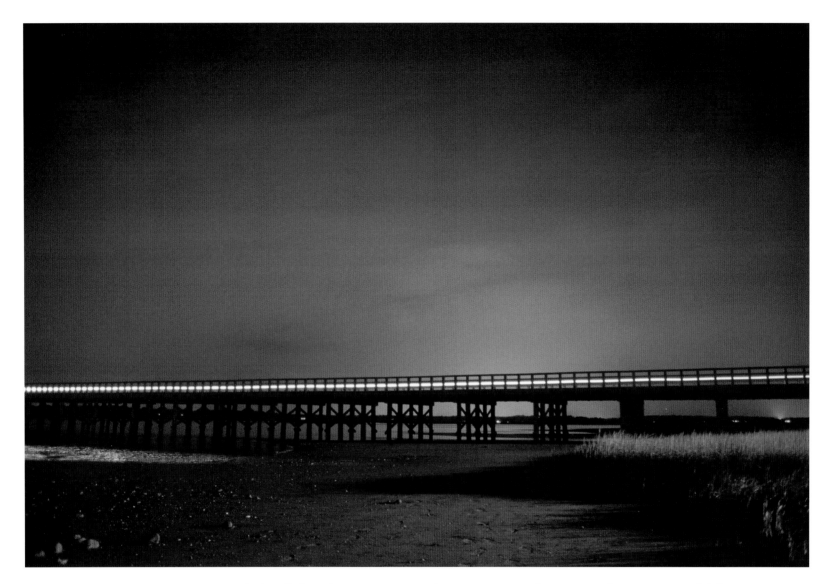

A time exposure captures the headlights of cars crossing Duxbury's iconic Powder Point Bridge. Spanning tidal flats and a salt marsh, the bridge provides access to Duxbury's six-mile-long barrier beach. The wooden bridge is said to be the longest of its kind in the United States.

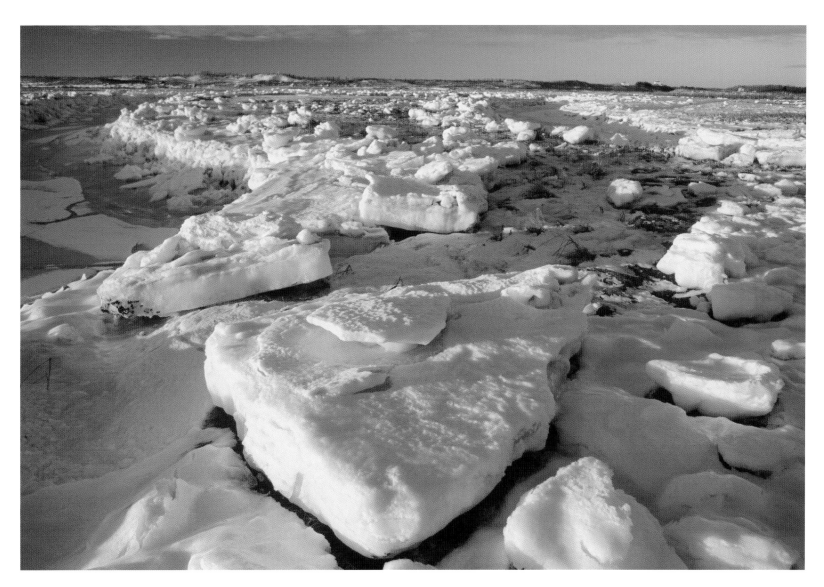

Snow-covered rocks and slabs of sea ice give a surreal appearance to a Duxbury landscape.

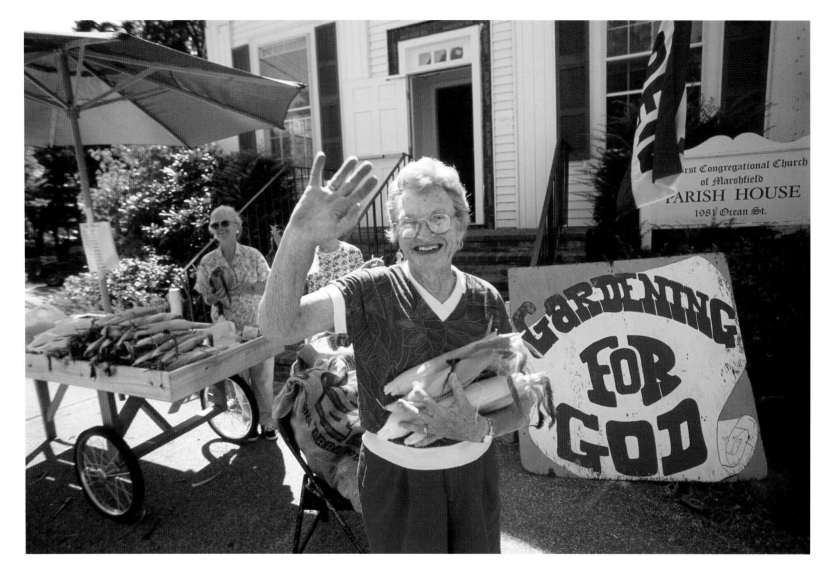

Dorothy Marshall and other women from Marshfield's First Congregational Church welcome customers to the church's
farm stand. Organized in 1632 by Edward Winslow, who settled Marshfield on land granted to him by the
Plymouth Colony Court, the church is the oldest continuous Congregational church in North America.
The area, once rich with farmland, still seems to be yielding a bountiful crop.

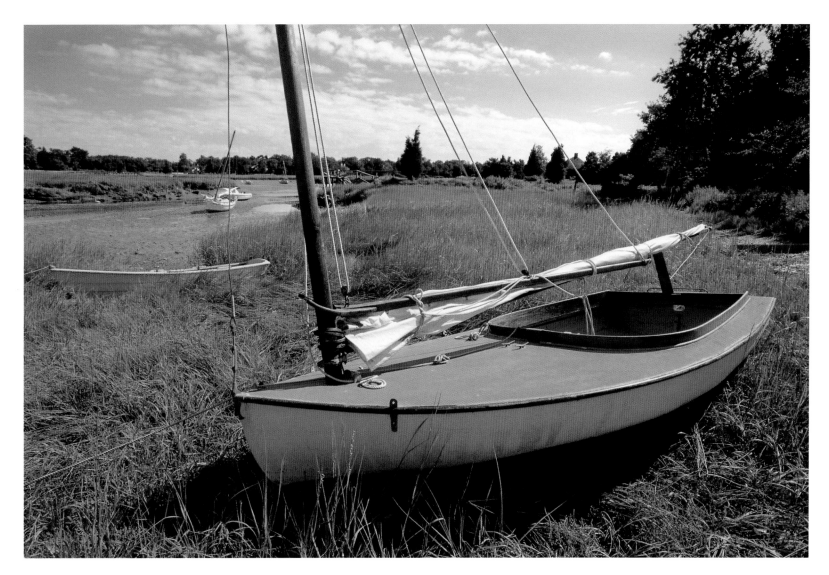

Salt marsh grass provides a soft cradle for a sailboat stranded by the tide on Duxbury's Bluefish River. Settled as
"Duxberie" in 1630 by several Pilgrim families, including those of John Alden and Myles Standish,
Duxbury was the second town created in the Plymouth Colony. It was on a rise of land
near the Bluefish River that John Alden built his original home.

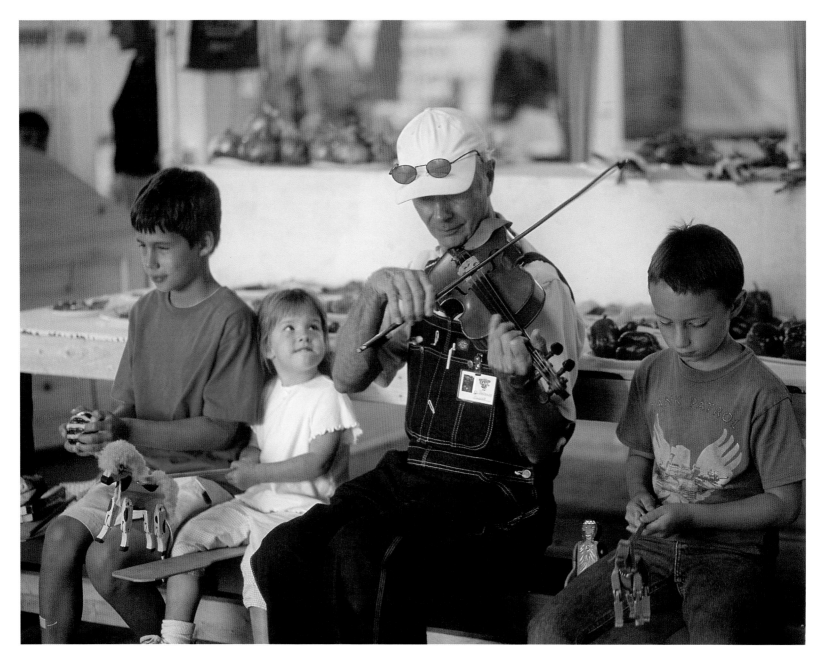

At the Marshfield Fair, the oldest county fair on the South Shore, children learn folk music and games. Sponsored by the Marshfield Agricultural and Horticultural Society, the ten-day fair has been a "blue-ribbon" institution on the South Shore since 1868.

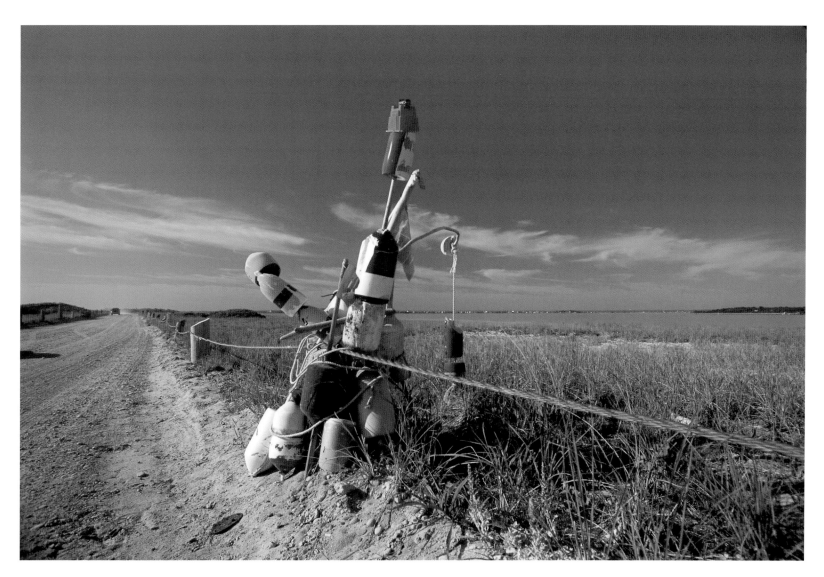

Is it art? A colorful beach sculpture of salvaged buoys decorates the sandy road to the Gurnet, a summer cottage community
at the outermost point of Duxbury Beach. The Gurnet promontory, which actually lies in Plymouth, can be reached
only by four-wheel-drive vehicles. Pilgrim fathers gave the headland the name "Gurnet's Nose,"
after similar English headlands where gurnet fish were caught.

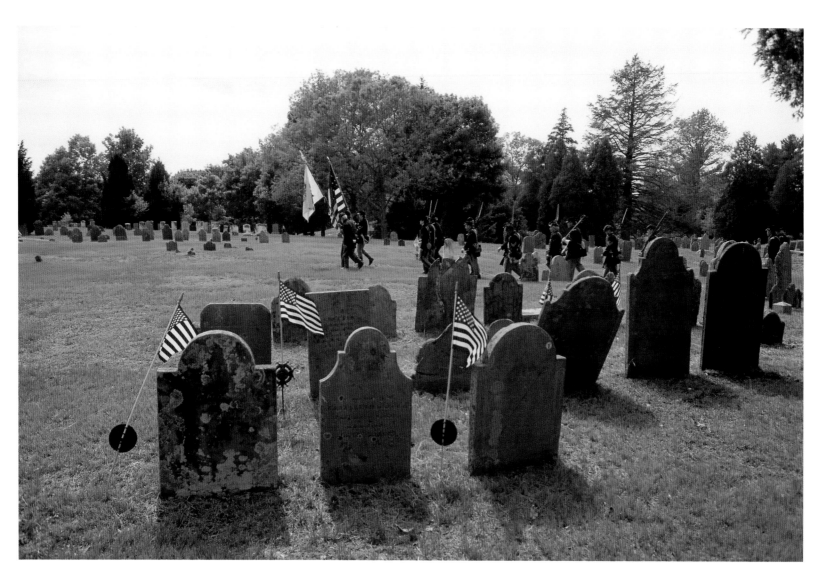

Civil War re-enactors march through Pembroke Cemetery for a Memorial Day tribute to the town's fallen heroes.
Originally part of Duxbury, Pembroke was incorporated in 1712—though it was originally settled
in the 1640s on a land grant from Myles Standish.

Considered the most architecturally significant building in Duxbury, the Nathaniel Winsor, Jr. House, built in 1807,
is based on designs by Charles Bulfinch. Winsor began his professional career as a carver of figureheads
in his father's shipyard and later inherited the family's shipbuilding enterprise. The Winsor family
was one of several prominent Duxbury merchant families whose fortunes were made during
the great age of sail. The elegant house is now the headquarters
of the Duxbury Rural and Historical Society.

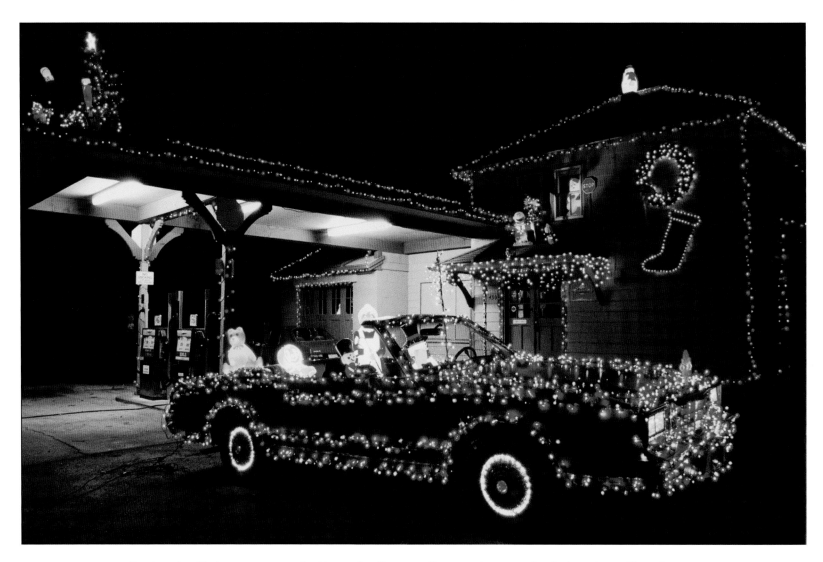

During the Christmas season, the Peters family goes all out to decorate the Cedar View Filling Station in Marshfield's Cedar Crest neighborhood.

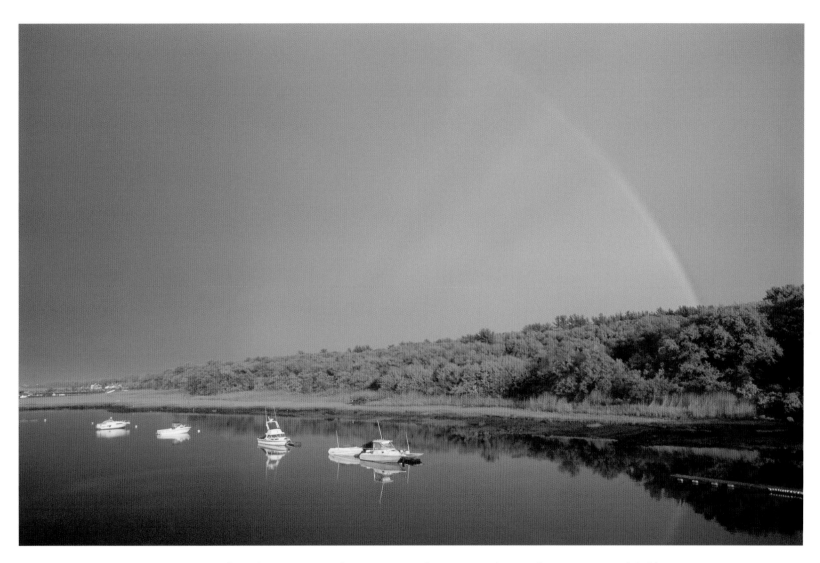

A snippet of rainbow appears after a summer shower over the North River in Marshfield.

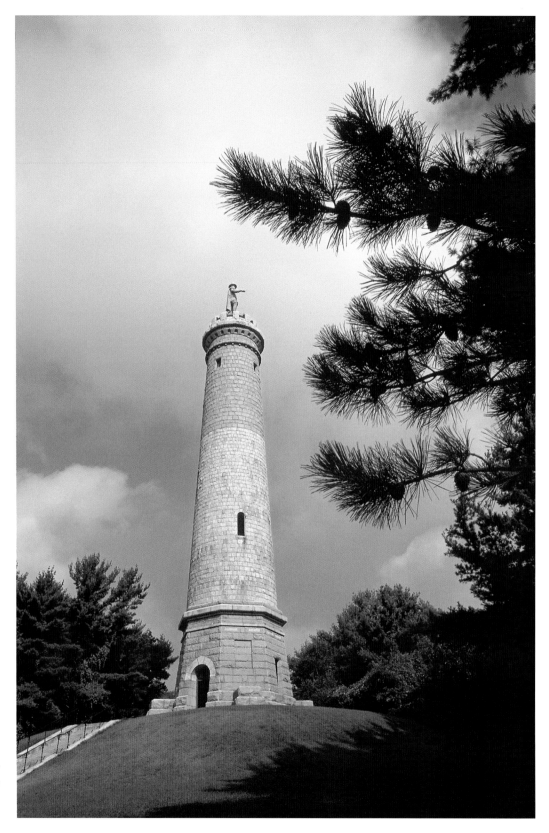

The Myles Standish Monument sits atop Captain's Hill in Duxbury. The 116-foot granite obelisk, crowned with a commanding statue of Standish holding the Plymouth Colony charter, honors the charismatic leader of Plymouth Colony. A monument-top viewing area, more than 200 feet above sea level, offers spectacular panoramic vistas of the South Shore.

Built in 1706, the Pembroke Friends Meeting House (right) is the second oldest Quaker meeting house in the country. Decades before the American Revolution, during which Pembroke residents played a key role in urging the overthrow of British rule, Quaker pacifists settled in Pembroke.

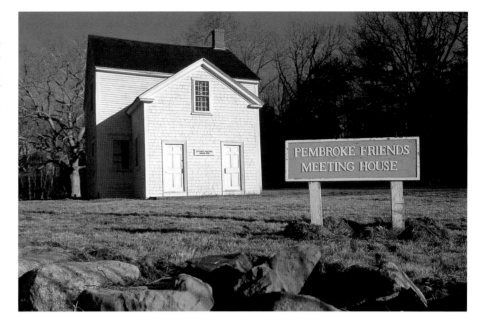

In a bucolic scene out of yesteryear, horses graze in the pasture at Wedgewood Farm in North Pembroke (below).

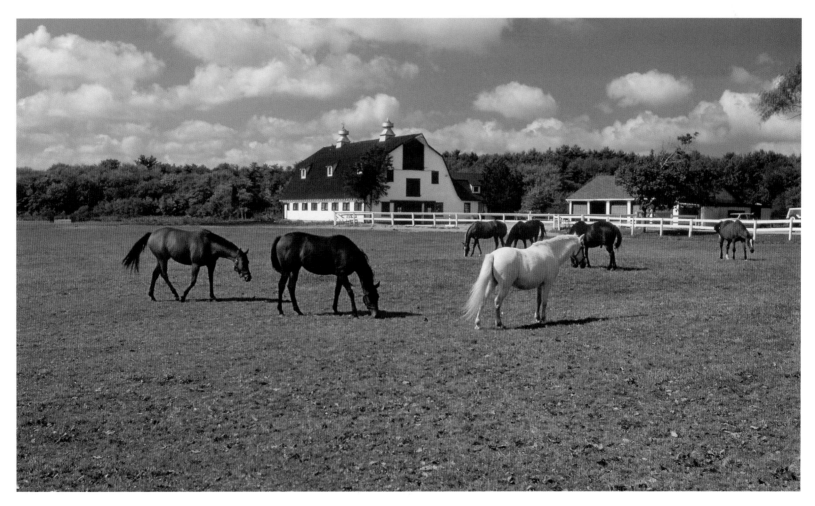

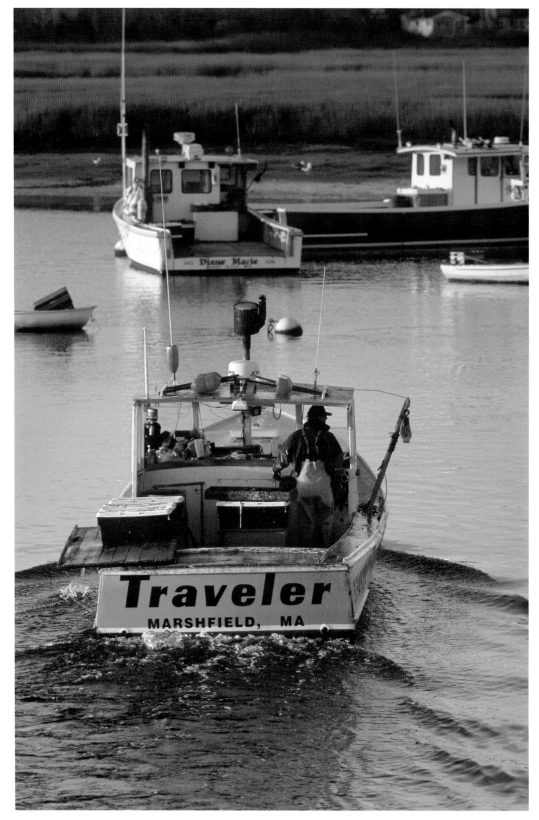

Traveler returns with its lobster traps to Marshfield's Green Harbor in the late afternoon. One of Marshfield's distinct villages, Green Harbor is home to a large lobster boat fleet that lands more lobsters than other ports in Massachusetts.

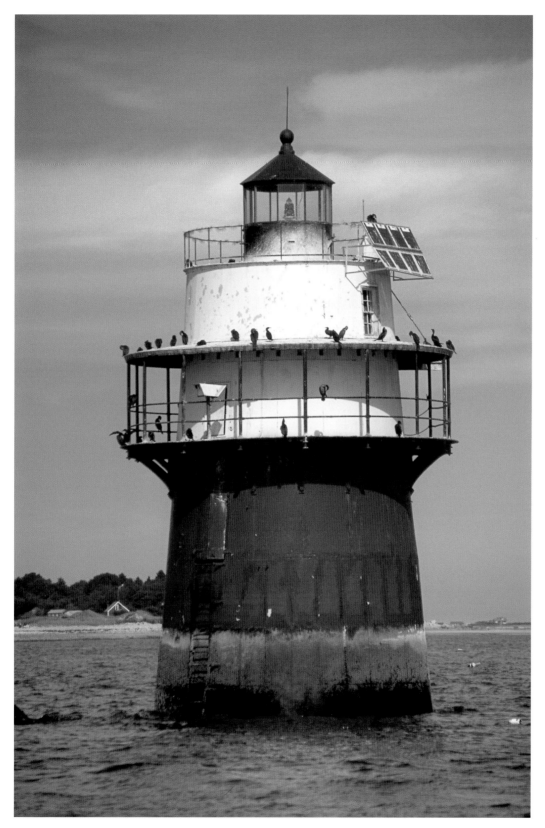

Officially known as Duxbury Pier Light, but fondly known as Bug Light, or simply "the Bug," the cast-iron beacon was activated in 1871 to mark the shoal off Saquish Head. With the light facing demolition in 1983, concerned residents organized Project Bug Light to repair, restore, and maintain the historic structure. The group has since changed its name to Project Gurnet and Bug Light to reflect concern for both lights.

CARVER, KINGSTON, & PLYMOUTH

Anchoring the southern end of the South Shore are the towns of Carver, Kingston, and Plymouth, all sharing Pilgrim history. Kingston was originally settled as the North End of Plymouth, the first town in New England. Carver, at one time the cranberry capital of the world, celebrates its Pilgrim ties every November when the native American fruit, enjoyed as part of the First Thanksgiving in Plymouth, takes its honored place on Thanksgiving tables across America.

From Plymouth, where an earnest group of Pilgrims stepped ashore in 1620, half dying that first terrible winter, the Old Coast Road pushed north to Boston. In the short span of a generation, the South Shore had been settled.

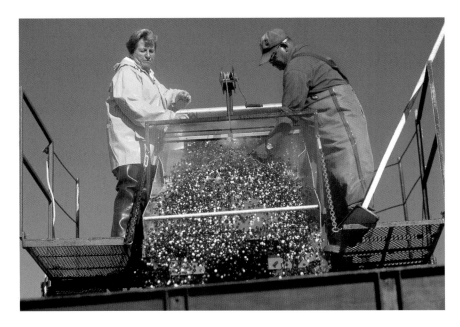

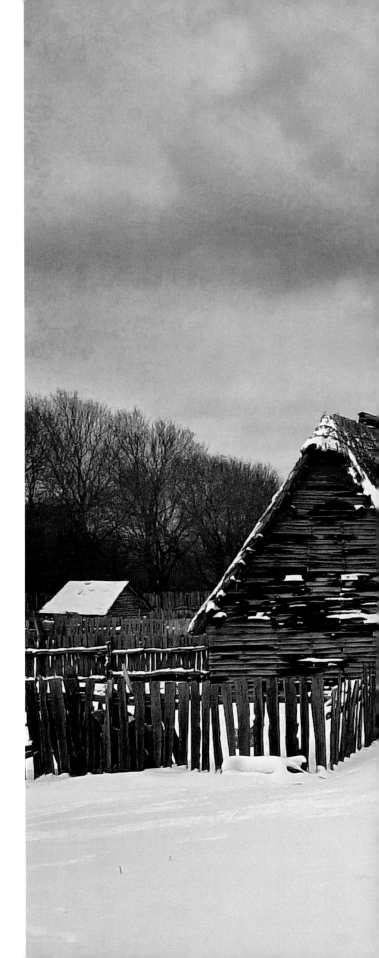

Farmers harvest cranberries in Carver (above). At Plimoth Plantation (right), a living-history museum of seventeenth-century life, a Pilgrim carries firewood to warm the modest timber-framed houses.

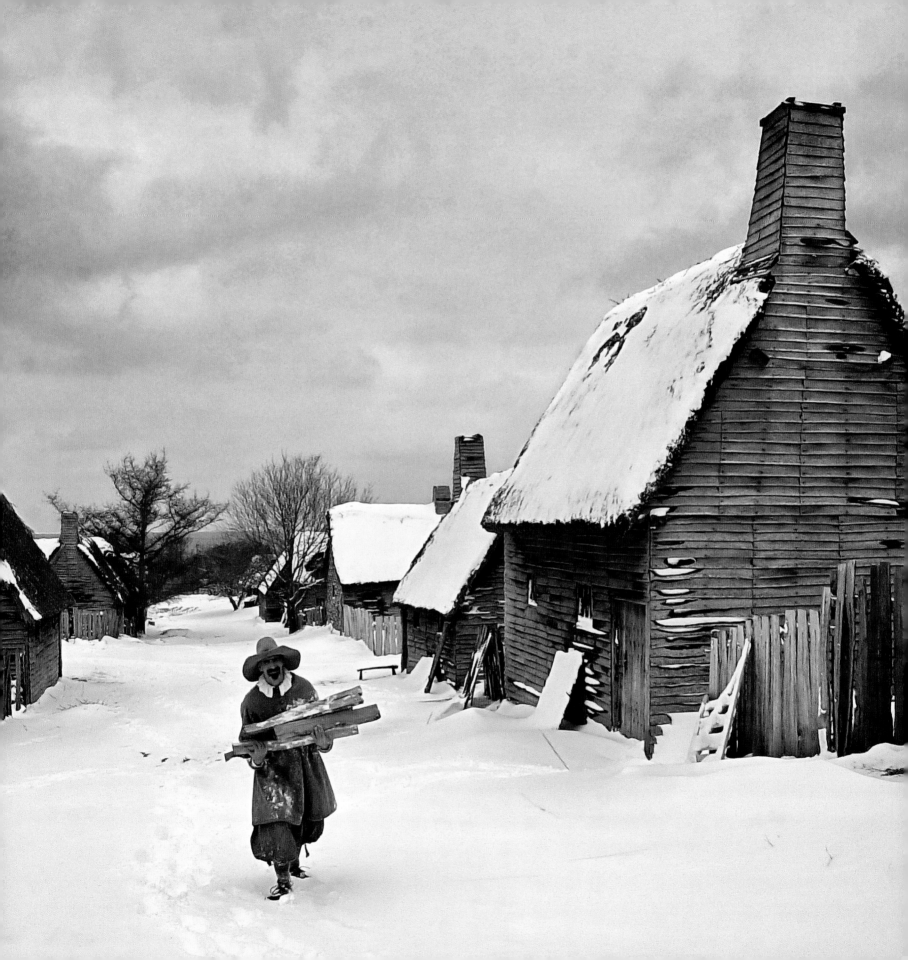

Dusk falls on Saquish, a charming cottage community at the "heel and toe" of the Duxbury Beach "boot." With no electricity or running water, Saquish (geographically part of Plymouth) is truly a getaway in the dunes.

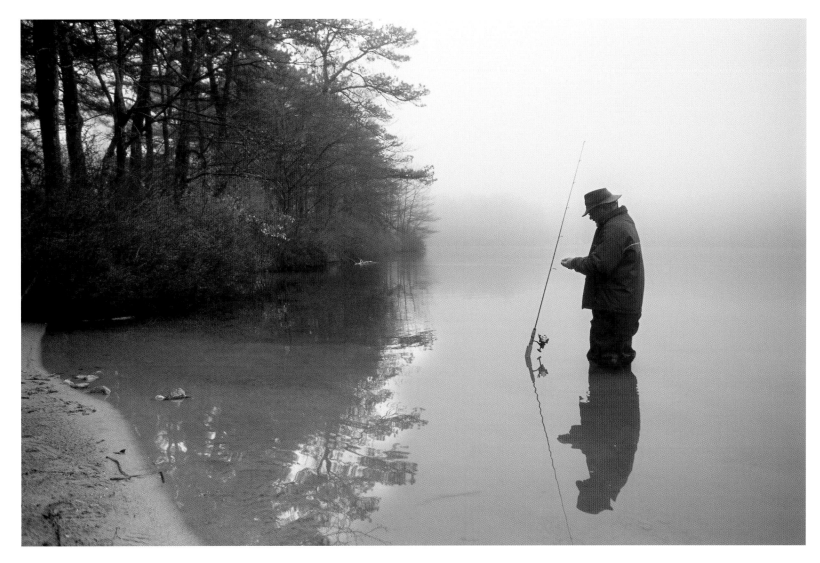

An angler baits his hook for an early-morning cast into the placid waters of Little Pond at Plymouth's Morton Park. The park, a 180-acre forested preserve, was given to the town by a group of civic-minded citizens in 1889. The Friends of Morton Park works to preserve and protect the scenic area from overuse and degradation.

Leyden Street, "First Street," in downtown Plymouth, is the site of the original Pilgrim Village. Along the narrow path, originally paved with cobblestones, the Pilgrims built rough, crude log cabins with roofs of thatched marsh grass and windows of oiled paper. Historic markers on the street identify the location of those first houses, now replaced by eighteenth-century, and more recent, homes.

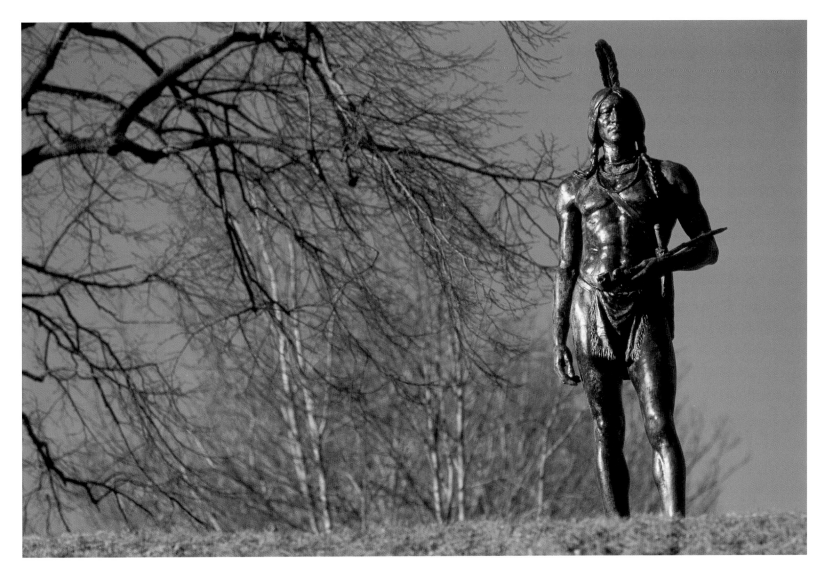

A bronze statue of Massasoit seems to be striding atop Coles Hill overlooking Plymouth Harbor. Built in 1921 by Cyrus E. Dallin, the statue honors the Wampanoag sachem (chief) who befriended the Pilgrims and helped them survive the harsh, bitter first winter. The Wampanoag people, whose name means "Children of the Dawn," have lived in southeastern Massachusetts for more than ten thousand years.

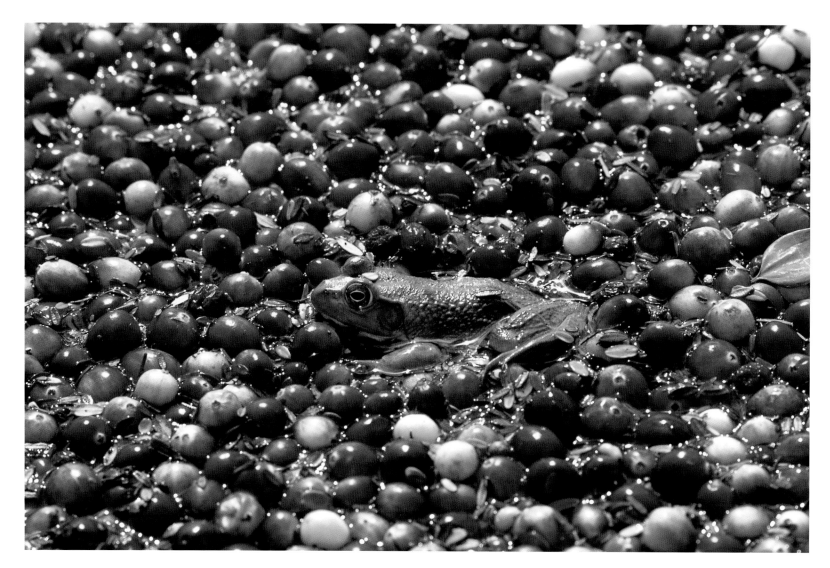

A frog floats in the bog. An air bladder in the cranberry enables it to float to the surface for a wet harvest. A native fruit that grew in natural bogs during colonial days, cranberries were first cultivated on Cape Cod during the mid-nineteenth century. By the 1940s, Carver was producing more cranberries, "red gold," than any other town in the country and remains today one of the few New England towns with a significant agricultural industry.

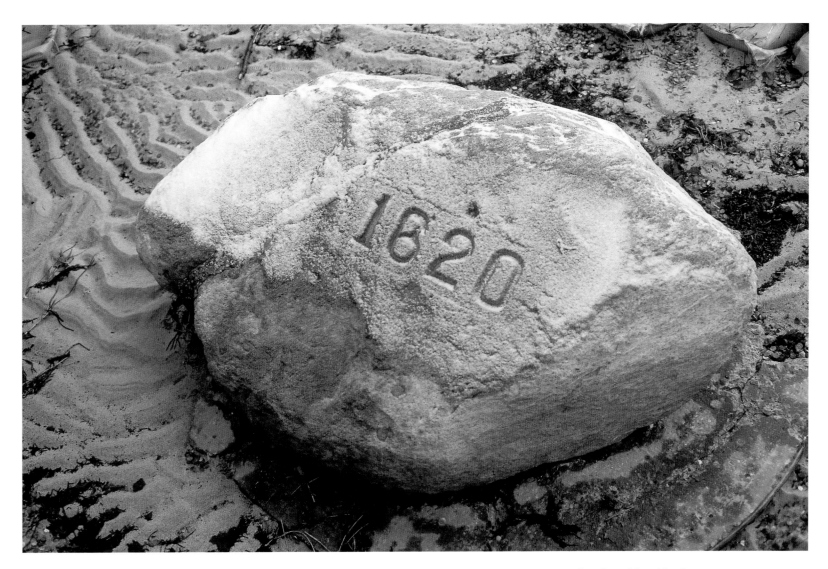

More than one million visitors come each year to Pilgrim Memorial State Park to see the glacial boulder known as Plymouth Rock, which symbolizes the courage and faith of the Pilgrims. Here on the Plymouth waterfront, according to legend, is the spot where the *Mayflower* passengers stepped ashore and founded the first permanent colony in New England.

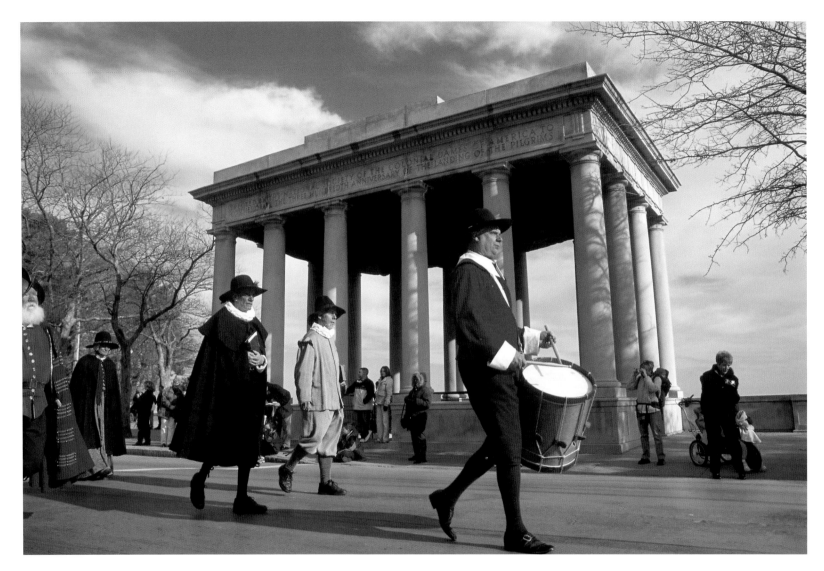

Plymouth Rock, the nation's first national landmark, is safely housed in a classical canopy designed by the eminent architectural firm McKim, Mead & White. During the annual Pilgrims Progress Parade, fifty-one costumed "Pilgrims"—representing the fifty-one original Pilgrims who survived the first terrible winter in Plymouth—march from the Mayflower Society past Plymouth Rock to Burial Hill.

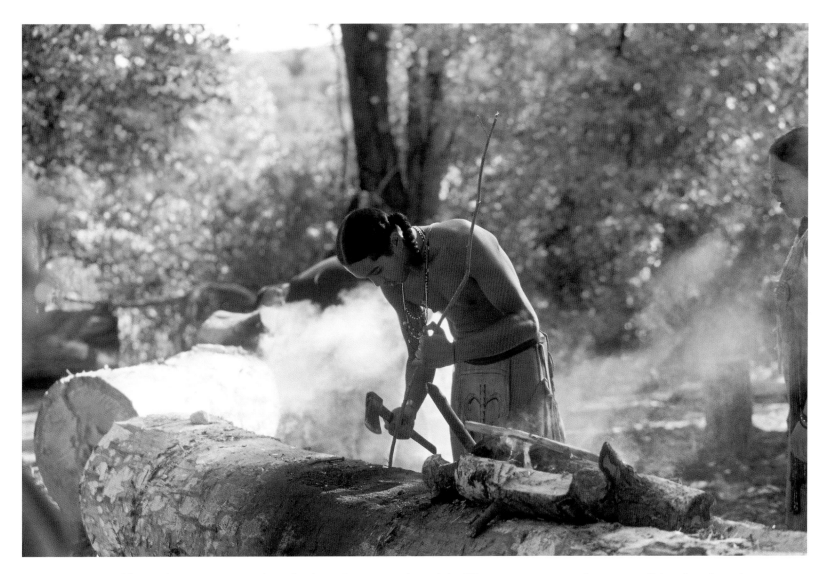

At Hobbamock's Homesite at Plimoth Plantation, a member of the Wampanoag community uses traditional tools and methods to construct a canoe. At the homesite, Native Americans speak from a modern perspective to teach visitors about the history and culture of the Wampanoag people. Hobbamock, a counselor to the Wampanoag leader Massasoit, came to live in Plymouth in 1621 and served as a guide and interpreter for the colonists for twenty years.

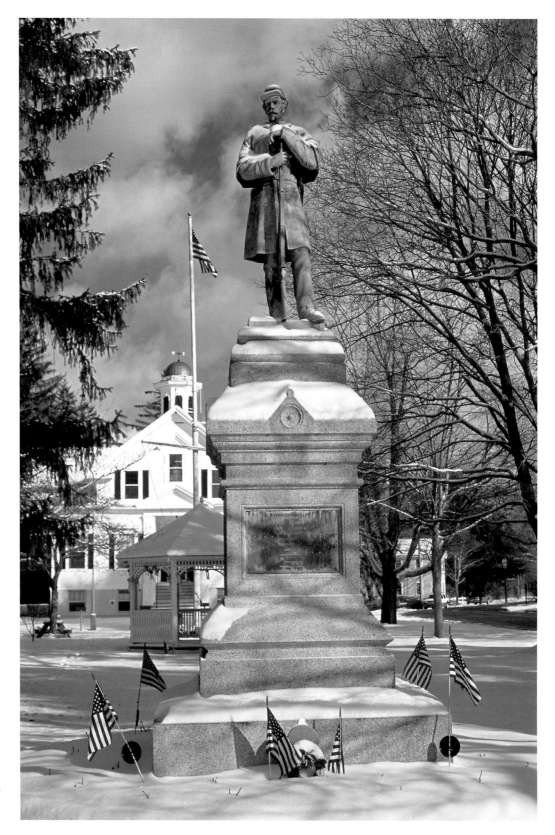

A blanket of snow covers the Civil War Memorial in the historic Kingston Burying Ground.

Harold Boyer, one of the elders of the Old Colony Club in Plymouth, sits surrounded by historic photographs and memorabilia. Organized in January 1769, the Old Colony Club— "where gentlemen meet"—is the oldest men's club in the United States, a social club formed to honor the arrival of the Pilgrim Fathers. The club memorializes the Pilgrims' landing each year on Forefathers Day.

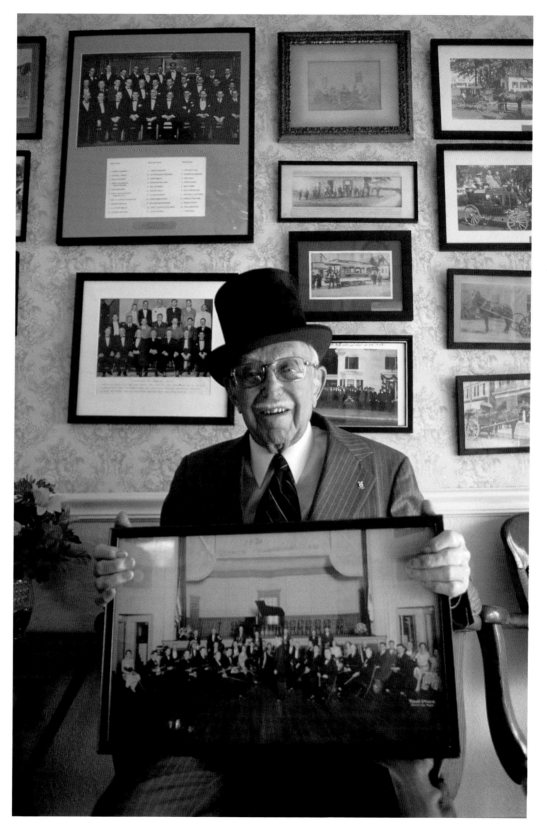

113

In Plymouth—at the far end of Duxbury's barrier beach—Gurnet Light (above) warns of shoals and keeps watch over the entrance to Plymouth Harbor. The octagonal wooden lighthouse, also known as Plymouth Light, originally had a twin when built in 1843. They replaced an earlier set of twin lighthouses—America's first twin lights—at the site, which was established as a station in 1768.

Few South Shore events are as anticipated as the annual "roundup" of cranberries (right). The harvest begins just after Labor Day and continues through October. During a wet harvest, bogs are flooded, and the mature berries are paddled loose from their vines, corralled by a floating boom, and vacuumed onto a conveyor.

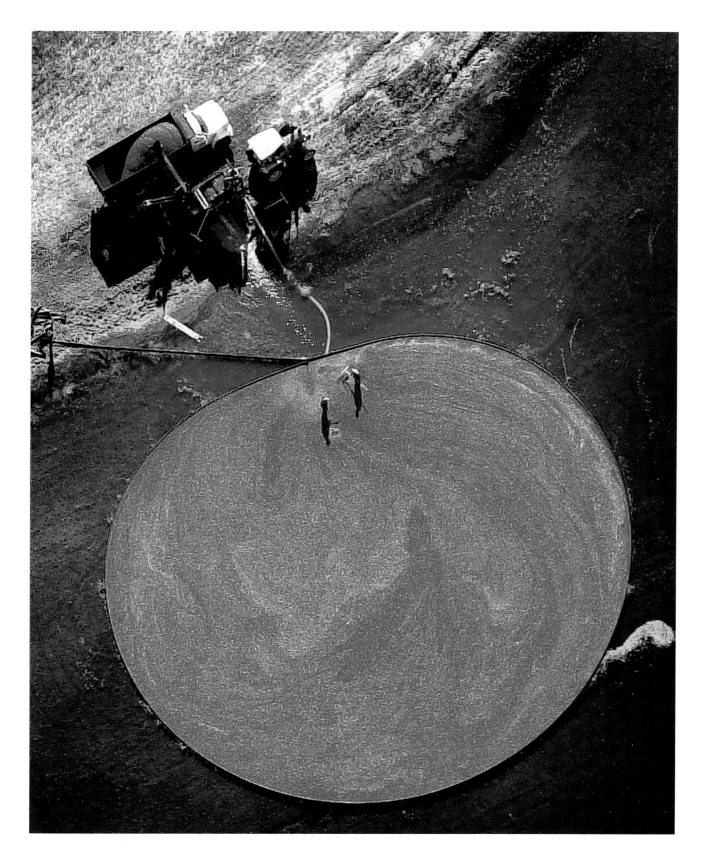

A lobster's-eye view of Plymouth Harbor. Today, the king of the crustaceans is one of New England's most esteemed
seafoods, but the lobster's scavenging nature prompted the Pilgrims to declare it "fit only for pigs."
Not many years ago, the lobster was so plentiful it was used for bait.

A handsome antique home graces a Kingston street. Originally settled as the North End of Plymouth, Kingston was incorporated as its own town in 1726. Townspeople took advantage of Kingston's location on the Jones River to develop a thriving shipbuilding industry. Governor Bradford's *History of Plymouth Plantation*, an account of the Pilgrims' journey to the New World, was preserved in manuscript form in a Kingston home for more than two hundred years.

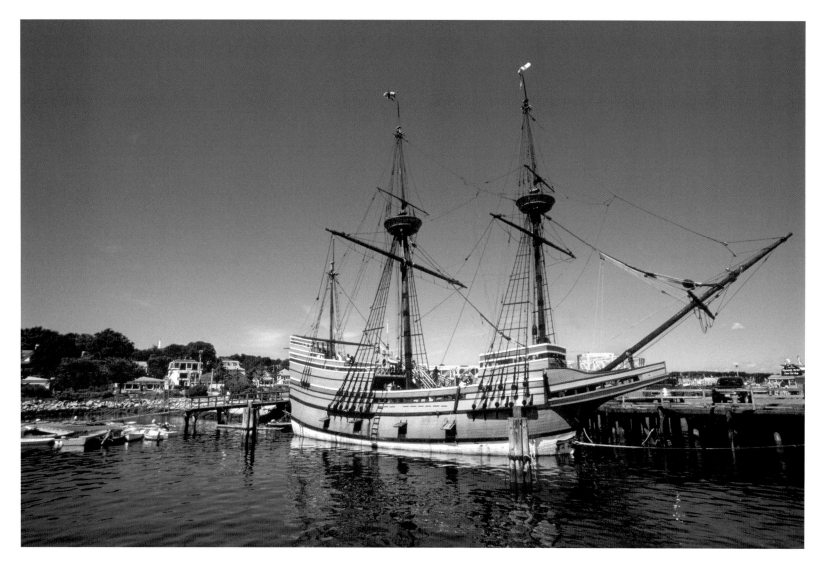

A salty breeze blows across the deck of the *Mayflower II* in Plymouth Harbor. The vessel is a full-scale reproduction of the seventeenth-century sailing ship that brought the intrepid band of Pilgrims to the New World in November 1620. Square-rigged and 106 feet long, the original *Mayflower* was a merchant vessel employed in the wine trade before being hired by the Pilgrims for their sixty-six-day voyage.

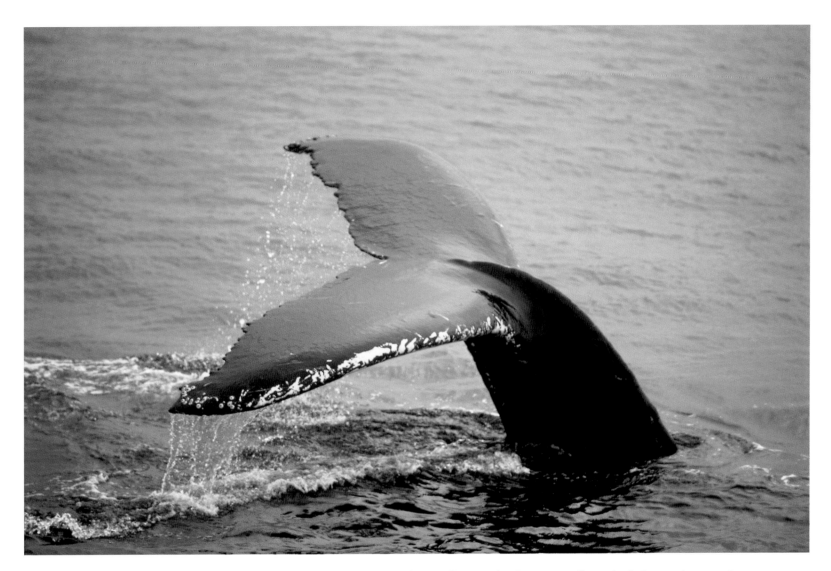

Plymouth's busy harbor, home to a working commercial fishing fleet, is also home to a fleet of whale-watch excursion boats that take visitors out to Stellwagen Bank, where magnificent humpback whales, seasonal visitors to local waters, gorge on small schooling fish. The Stellwagen Bank National Marine Sanctuary, one of fourteen national marine sanctuary program sites, was established by Congress in 1992.

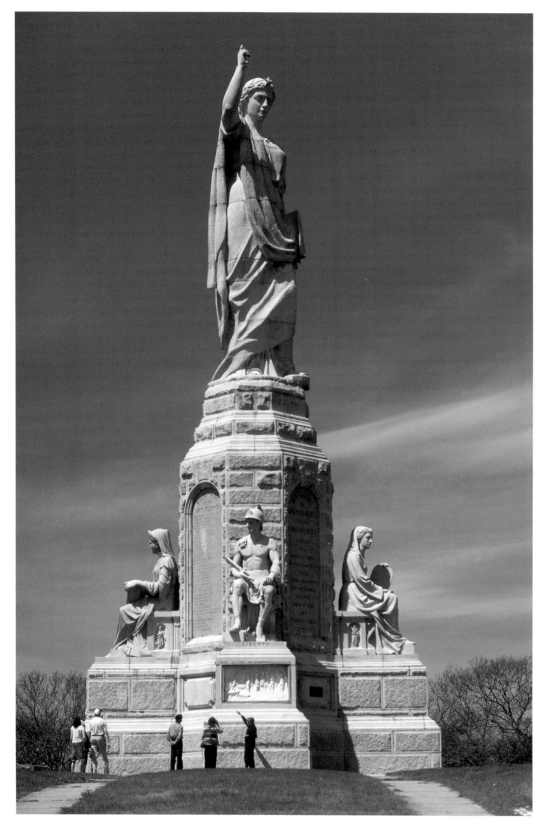

The National Monument to the Forefathers in Plymouth pays tribute to the Pilgrim settlers. Dedicated in 1889, the monument by Hammett Billings is the largest solid granite monument in America. The central figure of Faith is surrounded by four scenes of Pilgrim history and by the figures of Morality, Education, Law, and Liberty, symbolic of the principles upon which the Commonwealth of Massachusetts was founded.

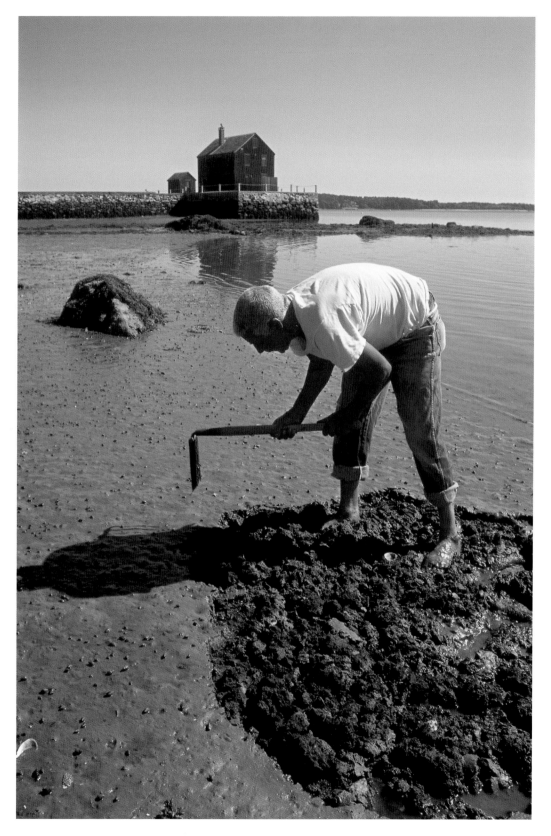

Dave Fernandez rakes for quahogs in the flats at Gray's Beach in Kingston. Also known as cherrystones, littlenecks, and hard-shelled clams, quahogs were valued by Native Americans, who made the hard shell into wampum, beads for bartering.

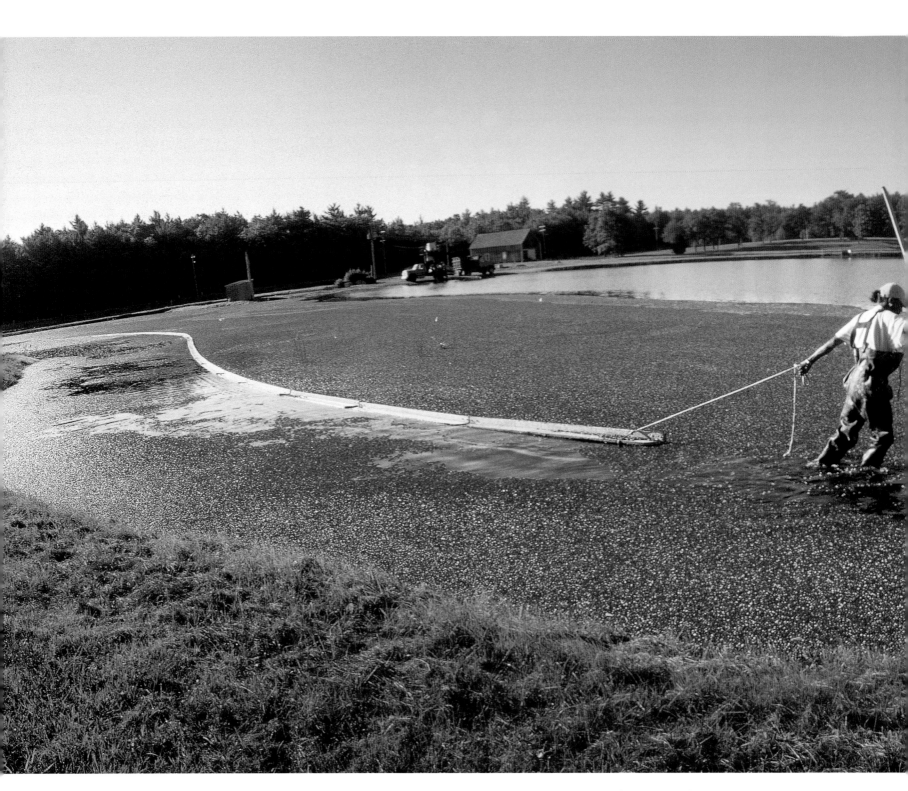

Cranberry farmers in Carver gather the tart fruit for a wet harvest. More than 85 percent of the Massachusetts cranberry crop is wet-harvested and used for sauces and juices. Berries intended for the fresh market are dry-harvested, raked off their vines by walk-behind machines and removed by bog vehicles or helicopters.

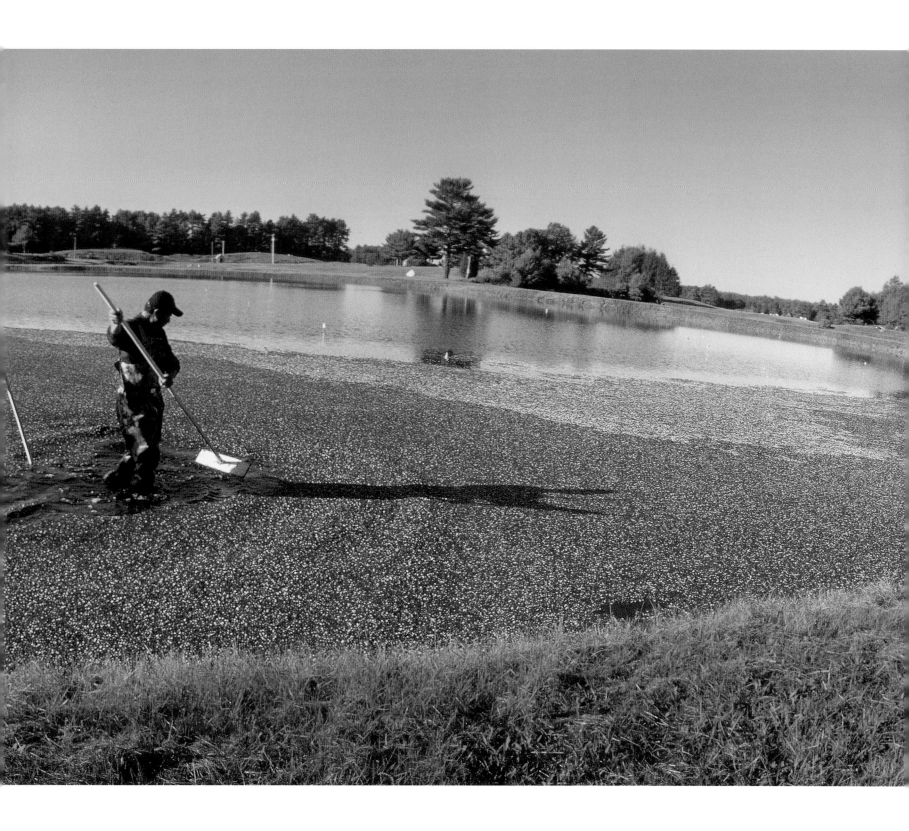

ACKNOWLEDGMENTS

MANY PEOPLE HELPED ME make this book a reality—and I would like to extend them my thanks. Foremost, a heartfelt thank-you to Amy Whorf McGuiggan, for recommending my work to publisher Webster Bull of Commonwealth Editions. Webster had the idea for a book devoted to the South Shore, which was sorely needed. Thank you to managing editor Penny Stratton and to production artist Anne Rolland, who put so many hours into making my images jump from the pages. Russell Scahill of Borsari Studio in Rockport helped immeasurably, making the images print-ready. I thank my wife, Judy, who transcribed all my cryptic notes on scraps of paper into legible photo identifiers. Thanks also go to the editors of the *Quincy Patriot Ledger,* Chazy Dowaliby and Terry Ryan, for their continued support and encouragement.

Much appreciation goes also to David Clapp and Norm Smith of the Massachusetts Audubon Society; Carlton Chandler of Marshfield Fair; to Carol City, Plimoth Plantation, and Jim Baker, Old Colony Men's Club. Thanks to The Trustees of Reservations; Rob Thompson; and John Stanwich and Tom Speer of the Adams National Historic Site. My appreciation to the Cohasset Yacht Club; Arthur Ducharme of the Church of the Presidents, Quincy; to Annie Davis, the Forbes House; to Donald Beers, Duxbury Harbormaster; and to Briggs Stable in Hanover.

Finally, many thanks to the residents of the South Shore, who have let me snap their pictures for over twenty years.

Greg Derr
Marshfield, Massachusetts
April 2005